TAPE IT
& MAKE
MORE

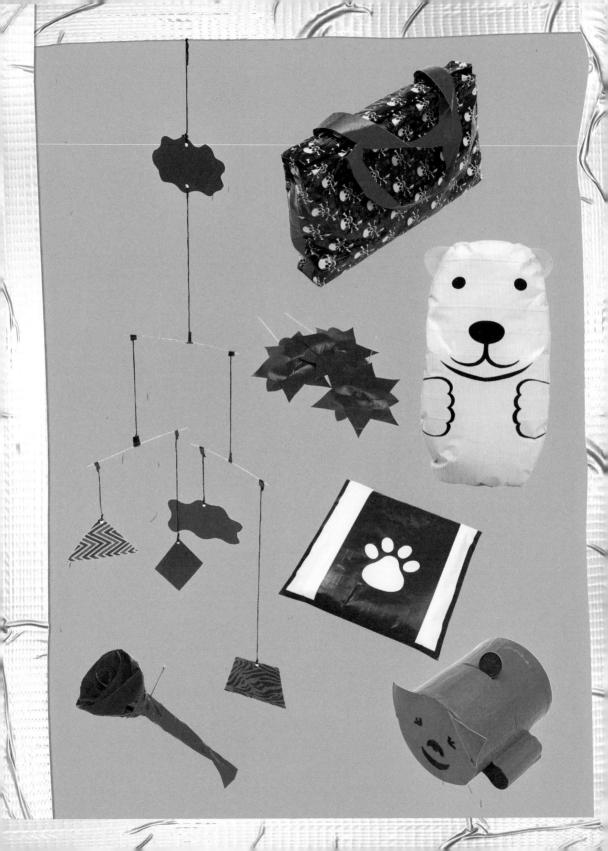

TAPE IT & MAKE MORE

Richela Fabian Morgan

101 DUCT TAPE ACTIVITIES

BARRON'S

A QUINTET BOOK

First edition for the United States and Canada
published in 2013 by Barron's Educational Series, Inc.

All inquiries should be addressed to:
Barron's Educational Series, Inc.
250 Wireless Boulevard
Hauppauge, NY 11788
www.barronseduc.com

Library of Congress Control Number: 2013938343

ISBN: 978-1-4380-0334-4

QTT.DUCT2

Conceived, designed, and produced by
Quintet Publishing Limited
The Old Brewery
6 Blundell Street
London N7 9BH
UK

Project Editor: Caroline Elliker
Consultant: Megan Hiller
Design: Rod Teasdale
Photography: Simon Pask
Lead Crafter: Gareth Butterworth
Assistant Crafters: Otokar Charvat, Tessa Sillars-Powell
Art Director: Michael Charles
Managing Editor: Emma Bastow
Publisher: Mark Searle

Printed in China by 1010 Printing Group Limited

Date of manufacture: May 2013

9 8 7 6 5 4 3 2 1

Contents

INTRODUCTION

THERE ARE MOMENTS IN LIFE WHEN DUCT TAPE SEEMS TO BE THE
LOGICAL SOLUTION TO A STRAIGHTFORWARD PROBLEM.

When I was a kid, my father used a long strip of the ubiquitous silver stuff
to cover an unsightly gash in the backseat of the family car. And while it
embarrassed me to sit on it, that quick fix lasted longer than the car. A few
years ago, I repeated history when the strap to my son's beloved backpack was
hanging on by a thread and I created a nearly undetectable new strap with
black duct tape. Like father, like daughter I suppose. We both saw duct tape as
a wondrous material that could quickly solve our predicaments.

We are all aware of the versatility of duct tape. Not only can it fix life's little
problems, it can also be the stuff of creativity. Duct tape can be an adhesive as
well as a material that can be cut, folded, or sewn. You can use it to make the
tiniest stickers or fabrics large enough to cover a dining table. The colors and
patterns have multiplied over time, mimicking fibrous textures and finishes that
inspire crafters to do incredible things.

In this book, I have given you another 101 duct tape projects that range
from stylish accessories to adventurous toys. There is something to suit crafters
of all levels, from the nine-year-old boy who wants to make his first kite to
the grandparent in need of a decorative letter banner for the holidays. Every
now and then you may also need some household items, or something easily
purchased at a craft or hardware store; just make sure you read through the list
of materials before beginning the project.

The colors and patterns used for each project are just a suggestion; substitute
as you wish because there are so many to choose from. A black hobo bag with
hot pink zebra interior may not be your cup of tea, but the combination of blue
chevron and orange linen may really float your boat. But pay attention to the
type of duct tape that you use because not all tapes are equal. There are some
that are made for heavy-duty jobs and may be thicker or stickier, but you can
still use these tapes at other times if you feel strongly about the texture and the
color. Finally, be sure to have an ample supply of parchment paper on hand,
and that your scissors or craft knife blades are oiled at all times.

Let's get started!

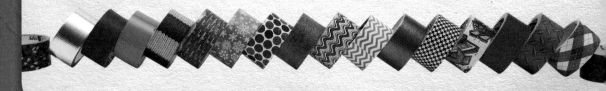

YOUR WORKSPACE, CLEANING, AND STORAGE

Duct tape is a gummy, sticky medium, and it can be quite unforgiving once you make a mistake. A smooth surface that is less porous than wood—like a Formica or melamine tabletop—is perfect to work on. It needs to be dust-free, so wipe it down with a damp cloth before you start work.

After working on your project, throw away any excess tape and properly clean the blades of the craft knife and scissors. The best way to remove the sticky gunk that builds up on some surfaces is to wipe them down with a dab of mineral oil or petroleum jelly. Store all rolls of tape in a transparent bin with a lid. This will enable you to see what colors and patterns you have without opening the bin, and keep the tape dust-free.

NECESSARY TOOLS

The following tools are used in every project in this book:
- Self-healing cutting mat, size 12 in. x 36 in. (30 cm x 90 cm)
- Craft knife (size 10), and extra blades
- Metal ruler with cork backing, 12 in. (30 cm) long
- Metal ruler with cork backing, 24 in. (60 cm) long
- Scissors
- Detail scissors

Keep these on your worktable, ready to be used at any moment. Any extra tools required are listed in each project's "Additional Tools" section.

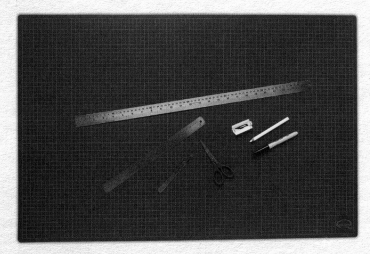

COLORS AND PATTERNS

Any colors of duct tape can be used for the projects in this book, not just those suggested in the instructions. If you can't get your hands on some patterned tapes, like zebra-print or camouflage, then that's all the more reason to be bold and creative in your color choices and combinations.

CREATING DUCT TAPE FABRICS

"SQUARING UP"
When making duct tape fabrics, you will need to "square up" the edges. This means that the edges of the fabric should be neatly trimmed using a metal ruler and craft knife, and that the edges should be perpendicular to each other. Use the grid on the self-healing cutting mat to ensure that each corner is exactly 90 degrees.

AVOIDING BUBBLES OR BUMPS
It is important to clean the cutting mat before laying down any tape. Wipe down the mat with a damp cloth; wipe again with a dry cloth. Run your hand across it to check for any stuck-on debris and wipe again if needed.

VARIETIES OF DUCT TAPE FABRIC

One-Sided Layered Fabric
For this fabric, the reverse side will remain sticky unless a thin cotton handkerchief, bandana, or polyester scarf is affixed to it to act as a lining.
1. Unwind the roll of tape across the surface of a cutting mat to the desired length. Cut off this strip with scissors.
2. Lay another strip of tape across the cutting mat, overlapping the first strip by ⅛ in. (3 mm). Repeat until you reach the desired overall size.
3. Square up the fabric. From one corner, gently peel off the tape across the diagonal to prevent the pieces from coming apart.

Double-Sided Layered Fabric

This duct tape fabric is slightly thicker than the single layer. For a two-tone look, use two different colors for the fabric's front and back sides— this not only looks more playful, it also allows you to make your project reversible.

1. Cut a piece of duct tape and place it on the cutting mat, sticky side facing up. Fold down the top edge to make a ¼-in. (6-mm) border.
2. Lay the second strip of tape sticky side down, across the first strip so they overlap by ¼ in. (6 mm) on both their top and bottom edges.
3. Flip it over so that the sticky side of the bottom strip is facing up. Lay another strip of tape, sticky side down, across the bottom strip, overlapping by the same measure. Repeat this step until you reach your desired height.
4. Once you've reached the desired height, flip the fabric over so that the last strip is at the bottom, with the sticky side facing up.
5. Fold over the bottom edge so that the sticky side is completely covered, then square up the fabric.

Woven Fabric

This simple up-and-over technique allows you to create checkered patterns, and also "boogie-woogie" Piet Mondrian-type squares. Or if you use a single color, the fabric takes on a more tactile quality which really transforms the duct tape into something else entirely.

1. Lay strips of tape horizontally across the cutting mat, sticky side down. Leave a slight gap between each strip, but make sure that each is no greater than 1/16 in. (1.5 mm).
2. Starting on the right edge, pull up every other strip and gently double them back on themselves. Then place a strip of duct tape vertically down, across those strips that remain stuck down. Replace the pulled-up horizontal strips on top of the vertical strip.
3. Pull the alternate horizontal strips up, starting on the right side and working toward the left. Vertically place another strip of duct tape to the immediate left edge of the first vertical strip, as close to it as possible without actually touching. Then, replace the lifted horizontal strips on the top of the new vertical strip. Repeat this step until you reach the desired size of the fabric.
4. Gently pry up the fabric's lower right corner, and pull it up off the cutting mat in a diagonal motion toward its upper left corner.
5. Put down the fabric with its sticky side facing upward. Cover the sticky surface with a thin cotton material, like an old t-shirt or bandana. Use your hands to smooth out any air bubbles, then square-up the edges of the fabric, and flip it over to reveal the front side of the finished woven fabric.

Accessories

Over the past few years, I've had moments when I pause and inwardly exclaim, "That would look GREAT if it were made out of duct tape!" I'm usually shopping with my daughter and my almost-teenage barometer-of-cool has picked up something that caught her eye: a pair of slippers, a plastic wrist corsage, or a diva-worthy beret. While she has already proclaimed the item worthy of being put into our shopping cart, I've made mental notes on how a great pattern duct tape with penguins or leopard print could really make them special. When this inner monologue is shared with my daughter, she mostly rolls her eyes. But there have been times when she thoughtfully agrees with me and I can claim duct tape victory!

Successful accessorizing is about choosing the right accents for an overall look. Whether you are in the mood for something subtle or bold, duct tape can transform an outfit. It can also say something about your personality or perhaps your mood. And with so many colors, patterns, and types of duct tape to choose from, the possibilities are endless.

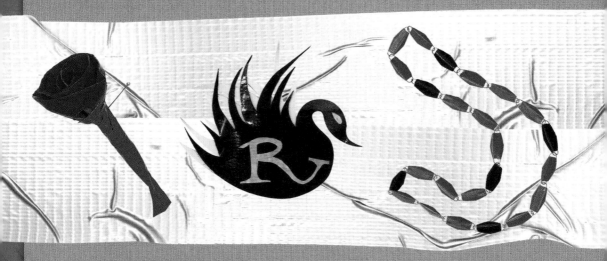

1. Flower Stud Earrings

Materials

» Silver coin metallic duct tape
» Lime green duct tape
» One pair of plain stud earrings

1 Cut a 3 in. (7.5 cm) strip of silver coin metallic duct tape and place it on your worktable with the sticky side facing up. Cut another 3 in. (7.5 cm) strip of lime green duct tape and place it squarely on top of the silver strip, sticky side facing down. Repeat to make two double-sided 3 in. (7.5 cm) pieces.

2 Fold one piece in half vertically so the silver is on the inside. Fold again horizontally to make a square. Cut out a rounded "V" so that the outer tips are on the open sides of the square and the closed corner is in the center.

3 Open the folds to make a flower with four petals. Trim the petals so they are all roughly the same size. Repeat Steps 2 and 3 with the second double-sided piece.

4 Nest one flower inside the other so that the petals are staggered. Take one of the earrings and use the sharp end to pierce the center of the flowers. Push all the way through. Repeat Steps 1 through 4 for the second flower earring.

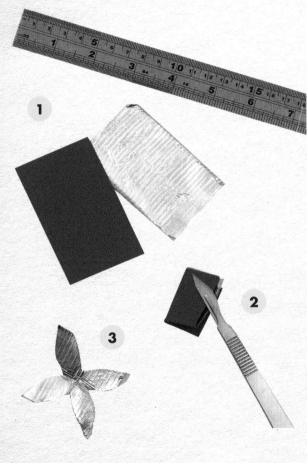

2. Fun 'n' Funky Dangling Earrings

Materials

» Multicolored wavy or chevron duct tape
» One pair of old dangling earrings

Additional Tools

» Circle stencils
» 1/8 in. (3 mm) hole punch
» Pliers

1 Make a double-sided duct tape fabric measuring at least 12 in. (30 cm) x 5 ½ in. (14 cm). Using the circle stencils, cut out two 2 ½ in. (6.5 cm) diameter circles and two 1 ½ in. (4 cm) diameter circles.

2 Take one 1 ½ in. (4 cm) circle. Cut out an inner circle measuring ½ in. (1.25 cm) diameter approximately ¼ in. (0.75 cm) from the top edge. Repeat for the second 1 ½ in. (4 cm) circle.

3 Take one 2 ½ in. (6.5 cm) circle. Cut out an inner circle measuring 1 in. (2.5 cm) diameter approximately ½ in. (1.25 cm) from the top edge. Repeat for the second 2 ½ in. (6.5 cm) circle.

4 Use the hole punch to make one hole at the top and another hole at the bottom of both 1 ½ in. (4 cm) circles. Punch one hole at the top of both 2 ½ in. (6.5 cm) circles.

5 With the pliers take apart the old earrings. Remove the chain links and use them to attach the 1 ½ in. (4 cm) circles to the 2 ½ in. (6.5 cm) circles.

6 Attach the earring hooks to the top holes of the 1 ½ in. (4 cm) circles.

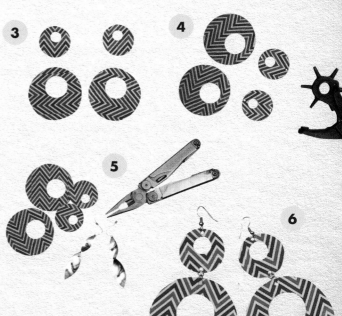

Materials

» Cha cha red duct tape
» Lime green duct tape
» Straight pin

3. Lapel Boutonniere

1 Cut a 9 in. (23 cm) strip of red tape. Take the bottom edge and fold it up, leaving an exposed sticky top edge approximately ¼ in. (0.75 cm) deep.

2 Turn the fabric vertically clockwise and hold the bottom edge. Begin to roll upward and inward. As you roll, crinkle the left side and pinch the right outer edge to create a growing spiral. This is the rose flower.

3 Cut a thin strip of red tape approximately ¼ in. (0.75 cm) wide and 4 in. (10 cm) long. Wrap the tape strip around the bottom of the flower to secure it.

4 Cut a strip of lime green tape approximately 6 in. (15 cm) long. Cut four "V"s into the top edge of the strip, each "V" measuring ¼ in. (0.75 cm) wide. Wrap the strip around the bottom of the flower, spreading out the "V"s at the base. Then roll the strip of tape to form the stem.

5 Use the straight pin to attach flower to a jacket lapel.

1

2

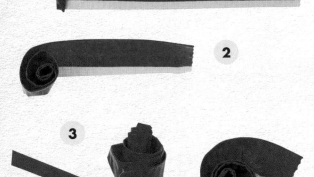
3

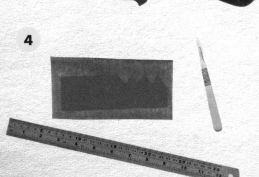
4

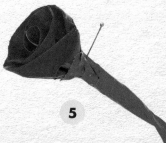
5

4. Wrist Corsage

Materials

» Cha cha red duct tape
» Leopard print duct tape
» Sour apple linen duct tape
» Self-adhesive Velcro® strip

1 Cut a strip of leopard print duct tape measuring 12 in. (30 cm) long. Fold bottom edge over as if you were starting to make a double-sided fabric. Then place a 12 in. (30 cm) strip of red duct tape on top, covering the sticky surface and slightly overlapping the folded edge of the first strip. Repeat with a second strip of red tape, making it about 3 in. (7.5 cm) wide. Flip over from right to left. There should be an exposed sticky edge along the top. This is your rose flower fabric.

2 Turn the fabric vertically clockwise and hold the bottom edge. Begin to roll upward and inward. As you roll, crinkle the left side and pinch the right outer edge to create a growing spiral. This is the rose.

3 Cut a thin strip of red tape approximately ¼ in. (0.75 cm) wide and 4 in. (10 cm) long. Wrap the tape strip around the bottom of the flower to secure it.

4 Cut slits into the flower approximately 1 in. (2.5 cm) apart to form the petals. Round off the edges of the petals.

5 Repeat Steps 1 to 4 to make a second rose.

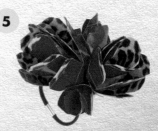

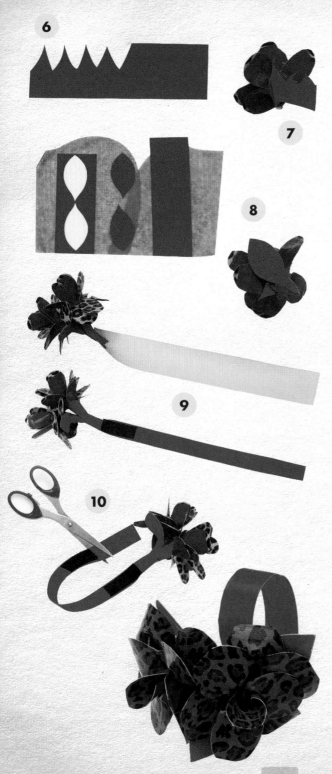

6 Cut a strip of sour apple duct tape approximately 6 in. (15 cm) long. Cut four "V"s into the top edge of the strip, each "V" measuring ¼ in. (0.75 cm) wide. Wrap the strip around the bottom of one rose, spreading out the "V"s at the base. Roll the strip of tape to form the stem. Repeat for the second rose.

7 Join the roses together by wrapping a 1 in. (2.5 cm) strip of sour apple duct tape around the stems.

8 Cut a 5 in. (13 cm) strip of sour apple duct tape and place it on your worktable with the sticky side facing up. Cut a second 5 in. (13 cm) strip of sour apple duct tape and place it squarely on top of the first strip, sticky side facing down. Cut out leaf shapes approximately 1 in. (2.5 cm) wide and 2 in. (5 cm) long. Using thin strips of sour apple duct tape, attach the leaves to the stems of the corsage.

9 Cut a 12 in. (30 cm) strip of sour apple duct tape and place it on your worktable with the sticky side facing up. Place the stem side of your corsage on the right outer edge of the strip. Fold the strip lengthwise so that it covers the stems. This is the wristband.

10 Remove one of the safety backings of the Velcro® strip and place it on the reverse of the wristband nearest the corsage. Wrap the wristband around your wrist for sizing. Remove the second safety backing of the Velcro® strip and press the other end of the wristband down on it to secure the band around the wrist. Undo the Velcro® strip and cut off the surplus band.

5. Diva Beret

Materials

» Leopard print duct tape
» White duct tape
» Black duct tape

1 Make two double-sided fabrics with leopard print duct tape on one side and white duct tape on the other, measuring at least 12 ½ in. (31.5 cm) square. Cut both fabrics into circles 12 in. (30 cm) in diameter. Set one circle aside. Draw and cut a circle 8 in. (20.5 cm) in diameter from the center of the remaining circle. You should now have a ring 2 in. (5 cm) wide and a circle 12 in. (30 cm) in diameter.

2 Cut a strip of leopard print duct tape approximately 20 in. (51 cm) long. Cut in half lengthwise to give two 20 in. (51 cm) strips. Cut "V" shapes along both sides of the strips, each "V" approximately ¼ in. (0.75 cm) wide and 1 in. (2.5 cm) apart.

3 Place the 2 in. (5 cm) wide ring on your worktable with the white side facing up. Place the 12 in. (30 cm) circle directly on top, leopard print side facing up. Using the strips from Step 2, connect the ring to the circle around the outer edges. Discard any surplus tape.

4 Cut a strip of black tape measuring 26 in. (66 cm) long. Fold bottom edge over as if you were starting to make a double-sided fabric. Place a second 26 in. (66 cm) strip of black duct tape on top, covering the sticky surface and slightly overlapping the folded edge of the first strip. Flip over from right to left. There should be an exposed sticky edge along the top.

5 Cut slits into the sticky edge of the brim to make tabs. Place the brim inside the beret with the sticky edge at the bottom and facing out toward the outer edge of the beret. Push the tabs down and against the inside of the main pocket, all around the opening.

6 Use a small piece of black duct tape to close the brim.

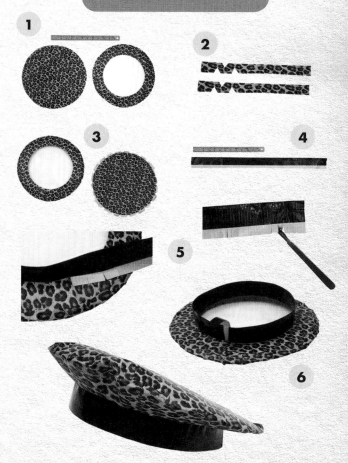

Materials

» Black duct tape
» White duct tape
» Pink metallic duct tape
» 1 ½ in. (4 cm) safety pin

Additional Tools

» Scrap paper
» White grease pencil

6. Fancy Swan Brooch

1 Make a double-sided fabric with black duct tape measuring 5 in. (13 cm) wide and 2 ½ in. (6.5 cm) high.

2 On a piece of scrap paper draw the silhouette of a swan large enough to fit on the black fabric. Cut out the swan shape.

3 Place the swan on top of the black fabric and trace it with a white grease pencil. Cut out the swan shape. Be sure to cut fine slits into the feathered areas.

4 Cut a 3 in. (7.5 cm) strip of white duct tape and place it on your worktable with the sticky side facing up. Cut a second 3 in. (7.5 cm) strip of white tape and place it squarely on top of the first strip, sticky side facing down. Cut out additional swan feathers and adhere them to the back of the black swan.

5 Cut out the first letter of your name from a piece of pink metallic tape. Adhere the letter to the center-front of the black swan.

6 Turn the swan over and tape the safety pin securely to the back.

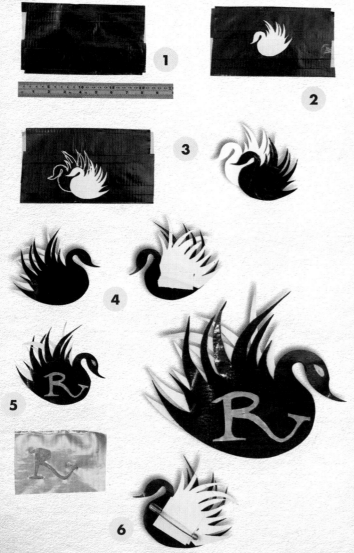

7. Cozy Slippers

1 Place your bigger foot on the unprinted side of the cereal box and draw around it. Cut out your foot shape and flip it from left to right. Use it to trace a second foot onto the cereal box. Cut out the second foot. Trace the pair of feet onto the corrugated cardboard and cut out.

2 Place the corrugated card feet directly on top of the cereal box feet. Cover with penguin duct tape to make the soles of the slippers.

3 Using the penguin duct tape, make two double-sided fabrics each measuring 7 ½ in. (19 cm) wide by 4 ½ in. (11.5 cm) high. Cut them into trapezoids that measure 5 in. (13 cm) wide at the top and 7 in. (17.75 cm) wide at the base. These are the fronts of the slippers.

4 Place a strip of penguin tape at the left and right outer edges of each front. Attach the fronts of the slippers to the soles by folding the exposed edges of these strips underneath it on both the left and right edges.

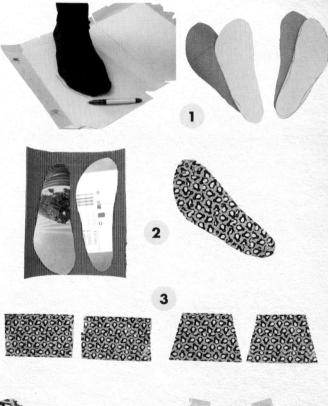

1

2

3

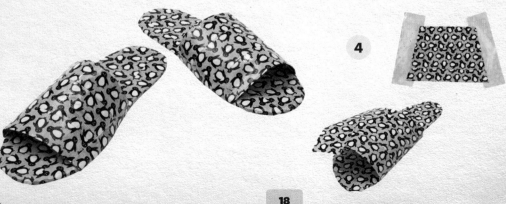

4

Materials

» Black and white gingham duct tape

8. Everyday Bow Tie

1 Cut a 9 in. (23 cm) strip of gingham duct tape and place it on your worktable with the sticky side facing up. Cut a second 9 in. (23 cm) strip of gingham duct tape and place it squarely on top of the first strip, sticky side facing down.

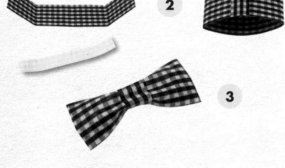

2 Vertically fold the two outer edges of the fabric in toward the middle. Each side should measure 2 ¼ in. (5.75 cm) long. Place a small piece of tape in the center to hold the sides in place to make the bow.

3 Unfold the bow tie. Cut a strip of tape measuring 3 in. (7.5 cm) long, then cut the strip in half lengthwise. Take one strip and tightly wrap it around the middle of the bow tie while carefully folding it in.

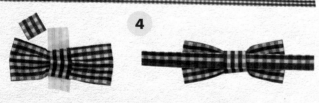

4 Cut a strip of gingham tape measuring 30 in. (76 cm) long. Fold lengthwise in thirds. This is the neck strap. With the second strip of tape from Step 3, attach the middle of the strap to the center front of the bow tie.

5 Cut a 1 in. (2.5 cm) strip of tape. Fold it into thirds vertically. Wrap it around one end of the neck strap to form a loop. Attach it with a small piece of tape. Take the other end of the neck strap and push it through the loop.

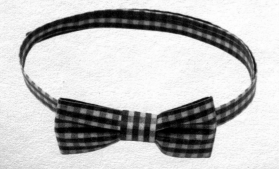

9. Beaded Novelty Necklace

Materials

» Electric blue duct tape
» Black duct tape
» 24 standard-size paper clips

1 Cut a strip of electric blue duct tape measuring 12 in. (30 cm) long. Place it on a gridded cutting mat. Cut three long triangle pieces from the strip, each one measuring 1 in. (2.5 cm) wide at the base.

2 Take a paper clip. Attach one of the triangle strips to it, aligning the 1 in. (2.5 cm) wide base along the edge of the paper clip. Slowly wrap the triangle around the paper clip until the apex of the triangle is at the center of the paper clip. This is one bead.

3 Attach a second paper clip to the clip at the center of the bead. Take another triangle and slowly wrap it around the second paper clip to make another bead. Repeat this step so that you have a string of three blue beads.

4 Cut a strip of black duct tape measuring 12 in. (30 cm) long and cut into three triangles as described in Step 1.

5 Attach a paper clip to the last blue bead. Slowly wrap a black triangle around the paper clip until you have a black bead. Set aside the remaining two black triangles.

6 Repeat Steps 1 to 3, then add a black bead, twice.

7 Repeat Steps 1 to 6 until you have a necklace with eighteen blue beads and six black beads in a 3–1–3–1 pattern.

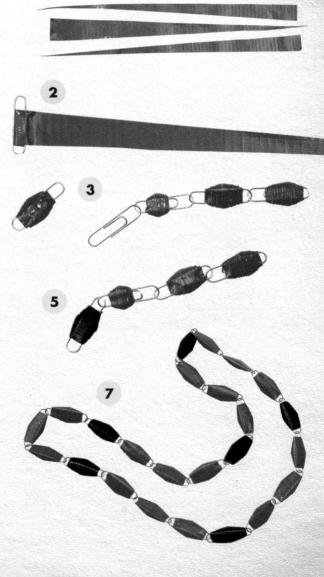

Materials

» Hot pink duct tape
» Black duct tape

10. Snazzy Shoelaces

1 Cut a strip of hot pink duct tape measuring 45 in. (115 cm) long (or a suitable length for your sneakers). Tightly fold the strip lengthwise approximately ¼ in. (0.75 cm) from the bottom. Repeat this fold. Fold the strip lengthwise from the bottom again, this time only ⅛ in. (3 mm). Repeat this last fold until you have a lace.

2 Cut two strips of black duct tape measuring approximately 1 in. (2.5 cm) square.

3 Tightly wrap each strip at the opposite ends of the shoelace.

4 Repeat Steps 1 to 3 for the second lace.

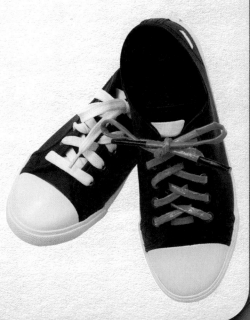

11. Fisherman-Style Rain Hat

Materials

» Yellow duct tape

Additional Tools

» Hat pattern from website:
www.richelafabianmorgan.com

1 Print out the patterns for the top and brim of the hat. Set aside the brim pattern.

2 Make two double-sided fabrics with yellow duct tape, each measuring approximately 16 in. (40.5 cm) wide by 9 in. (23 cm) high. Place them squarely on top of each other. Trace the hat top pattern onto the fabric.

3 Cut out the section pieces, making sure to penetrate through both layers of fabric. With strips of yellow tape, and working from the inside of the fabric, close up the "V"-shaped seam at the center of each piece. Then attach the two fabrics together at the outer edges, making sure the side lengths match. This is the main body of the hat: the long side is the back and the short side is the front.

4 Make two double-sided fabrics with the yellow tape, each measuring approximately 21 in. (53.5 cm) wide x 9 in. (23 cm) high. Place them squarely on top of each other. Trace the brim pattern onto the top fabric.

5 Cut out the section, making sure to penetrate through both layers of fabric. This is the brim.

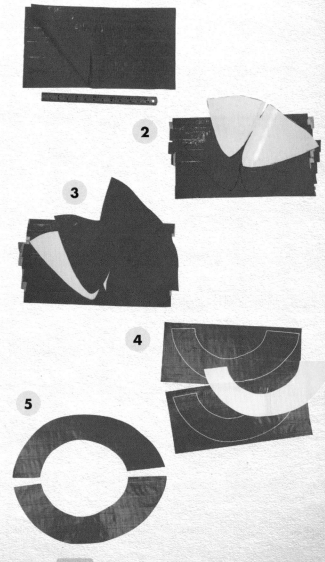

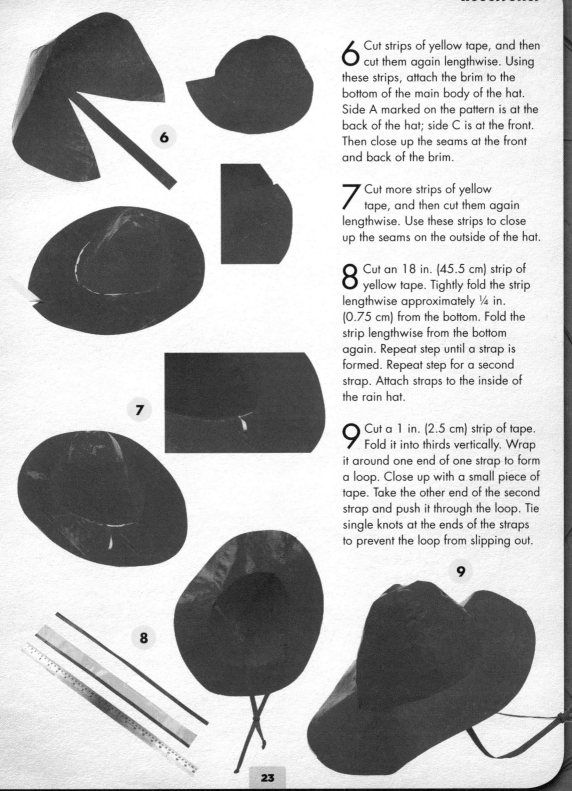

6 Cut strips of yellow tape, and then cut them again lengthwise. Using these strips, attach the brim to the bottom of the main body of the hat. Side A marked on the pattern is at the back of the hat; side C is at the front. Then close up the seams at the front and back of the brim.

7 Cut more strips of yellow tape, and then cut them again lengthwise. Use these strips to close up the seams on the outside of the hat.

8 Cut an 18 in. (45.5 cm) strip of yellow tape. Tightly fold the strip lengthwise approximately ¼ in. (0.75 cm) from the bottom. Fold the strip lengthwise from the bottom again. Repeat step until a strap is formed. Repeat step for a second strap. Attach straps to the inside of the rain hat.

9 Cut a 1 in. (2.5 cm) strip of tape. Fold it into thirds vertically. Wrap it around one end of one strap to form a loop. Close up with a small piece of tape. Take the other end of the second strap and push it through the loop. Tie single knots at the ends of the straps to prevent the loop from slipping out.

CHAPTER 2:

Housewares

Duct tape is past the novelty phase. Yes, you can make a coaster or placemat for the sake of making conversation. But duct tape housewares are now fully incorporated into the comfort and design of a home, thanks to designer patterns and matte finishes. No one will notice that the fancy pencil holder on your desk or the clever sponge dishes by the kitchen sink are made from duct tape, because duct tape doesn't resemble duct tape anymore—it's become something more.

The following projects run the gamut, from keeping your shelves clean to lighting a room to create an ambience. The colors used are suggestions and substitutions are encouraged. Want napkin rings with a patterned tape instead of gold chrome? Go for it. In fact, make several sets! You can also make seasonal shelf liners, or a dozen magnets using the same stencil but different color tapes. And as the décor in your home changes, make and remake these projects to suit your style.

Materials

» Black and white damask duct tape
» Mirror
» Sheet of cardboard equal in size to the mirror

Additional Tools

» Parchment paper

12. Mirror Frame

1 Trace around the edge of the mirror onto the cardboard.

2 Measure 2 in. (5 cm) inward from the outer edge of the outline, and draw a smaller version of the same shape as the mirror (a circle in the example pictured). Cut out this shape and discard the piece in the center. This will give you the mirror frame.

3 Place the cut-out cardboard frame onto the parchment paper. Cover the frame with strips of damask duct tape, running vertically with no space between each strip (they can overlap slightly). Leave approximately 1 in. (2.5 cm) of tape overhanging from the frame on all sides.

4 Flip the frame over and fold overhanging tape on the frame's inner side over onto the back of the frame. On the left and right sides, cut slits into the tape for easier wrapping. Place the mirror on to the frame (with the mirrored side facing downward) and wrap the overhanging duct tape over onto the back of the mirror, securing the frame onto it.

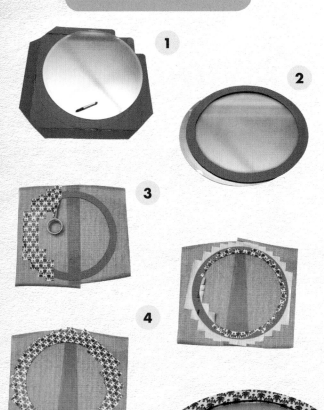

13. Rolled Tape Pencil Holder

1 Cut 26 strips of sour apple duct tape each measuring approximately 4 in. (10 cm) long. Roll each strip over one cotton swab. Repeat with the orange duct tape. You should have a total of 52 rolled strips.

2 Unspool the wire but do not cut it. Wrap the end of the wire once around one of the rolled strips approximately 1 in. (2.5 cm) from the top edge. Then attach each rolled strip, alternating colors, by wrapping the wire once around it. Cut off the excess wire, leaving a 3 in. (7.5 cm) tail.

3 Using a ruler and a pen, mark a border along the opposite end of the attached strips, approximately 1 in. (2.5 cm) from the edge. Wrap the wire once around each rolled strip to attach them. Cut off the excess wire, leaving a 3 in. (7.5 cm) tail.

4 Stand the joined strips up on one end to form a cylinder and use the 3 in. (7.5 cm) wire tails to join the ends together.

5 Use the orange duct tape to make a double-sided fabric large enough to cover the base of the cylinder. Place the cylinder on top of the fabric and measure the diameter of the inner circle. Remove the cylinder and use the compass to draw a circle onto the fabric.

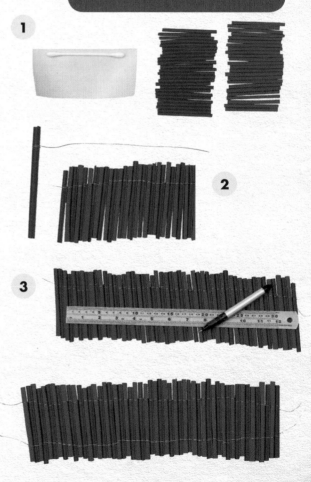

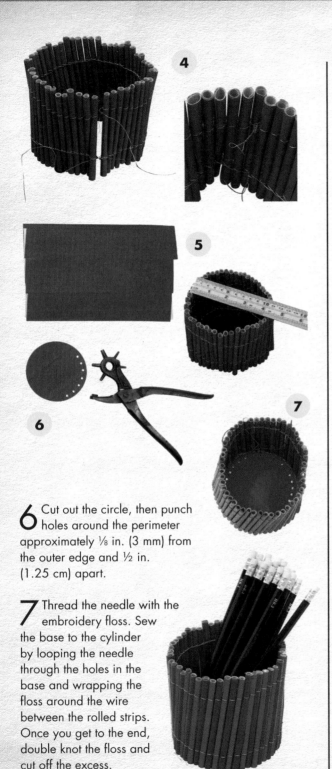

4

5

6

7

14. Striped Shelf Liner

Materials

» Yellow duct tape
» White duct tape

1 Measure the depth and width of the shelf you want to cover.

2 Make a double-sided fabric with the yellow and white duct tape, alternating colors to create a striped pattern.

3 Square up the sides so that the finished size is approximately ¼ in. (0.75 cm) smaller than the depth and width of the shelf.

2

6 Cut out the circle, then punch holes around the perimeter approximately ⅛ in. (3 mm) from the outer edge and ½ in. (1.25 cm) apart.

7 Thread the needle with the embroidery floss. Sew the base to the cylinder by looping the needle through the holes in the base and wrapping the floss around the wire between the rolled strips. Once you get to the end, double knot the floss and cut off the excess.

15. Shower Caddy

Materials

» Sour apple linen duct tape
» Transparent duct tape

1 Make a double-sided fabric with the sour apple duct tape measuring 7 in. (17.75 cm) wide by 5 ½ in. (14 cm) high. Square up the sides. This is the caddy base.

2 Cut a 12 in. (30 cm) strip of transparent duct tape and place it on your worktable with the sticky side facing up. Cut a second 12 in. (30 cm) strip of transparent duct tape and place it on top of the first strip, sticky side facing down. Cut the strip in half lengthwise, then cut it vertically to give four pieces, each 6 in. (15 cm) long. Repeat three times so you have twelve pieces.

3 Attach the strips to the perimeter of the base with transparent duct tape. Use tape on the front and back. Space the strips as evenly as possible, three on each side. These are the walls of the caddy. Trim excess tape at the ends.

4 Cut four small strips of transparent duct tape approximately ½ in. (1.25 cm) long. Pull the walls up so that they form a 90-degree angle to the base and attach them to the corners of the base with the strips of tape.

5 Run a strip of transparent duct tape across the middle of one of the walls. Turn the caddy and continue running the strip of tape across the middle of the next wall. Continue turning the caddy and running the tape across the middle until each side is covered. Trim the tape, leaving a 1 in. (2.5 cm) end, then stick this down to complete the wall. Repeat on the inside of the caddy, placing the tape directly on top of the first strip.

6 Cut a strip of transparent duct tape 26 in. (66 cm) long. Place it halfway along the top edges of the walls and around the perimeter of the caddy, overlapping the top by 1 in. (2.5 cm). Tape it closed and fold over to make the rim.

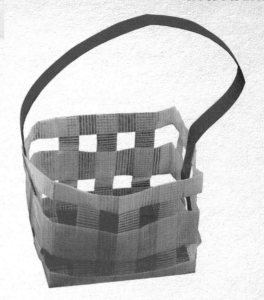

7

7 Cut a strip of sour apple linen duct tape approximately 30 in. (76 cm) long. Fold it in half lengthwise. This is the handle. With strips of transparent duct tape, attach it to the inside of a pair of opposing walls.

16. Picture Magnet

1 Cover the surface of the magnet with a single layer of blue paisley duct tape. Trim the edges.

2 Use the Art Deco Woman stencil to make a decorative sticker (see page 52). The hat should be black duct tape, the blouse silver, the face white linen, and the lips and hat band cha cha red. Assemble the sections on the parchment paper.

3 Carefully peel back the parchment paper and arrange the sticker on top of the magnet.

Materials

» Blue paisley duct tape
» White linen duct tape
» Black duct tape
» Silver coin chrome duct tape
» Cha cha red duct tape
» Flexible sheet magnet (any that is larger in size than a business card)

Additional Tools

» Art Deco Woman stencil on page 52
» Parchment paper

17. Square Planter

Materials

» Saddle leather or dark brown duct tape
» Lime green duct tape

Additional Tools

» Circle template

1 Make two double-sided fabrics with the saddle leather duct tape, one measuring 12 in. (30 cm) wide by 4 in. (10 cm) high and the other measuring 8 in. (20.5 cm) wide by 4 in. (10 cm) high. Square up the sides. Vertically fold the larger fabric into thirds to make three 4 in. (10 cm) squares.

2 Cut the smaller fabric in half so there are two 4 in. (10 cm) square pieces. Place one square at the top and the other square at the bottom of the larger fabric. Be sure to align the squares with the center section of the larger fabric. Attach them with 4 in. (10 cm) strips of saddle leather duct tape. This is the container of the planter. The center square is the base and the four outer squares are the walls.

3 Cut an 8 in. (20.5 cm) strip of saddle leather duct tape. Cut in half lengthwise, and then in half vertically to give four strips measuring approximately 4 in. (10 cm) by 1 in. (2.5 cm). Use these strips to close up the seams of the container at the outer edges of each wall.

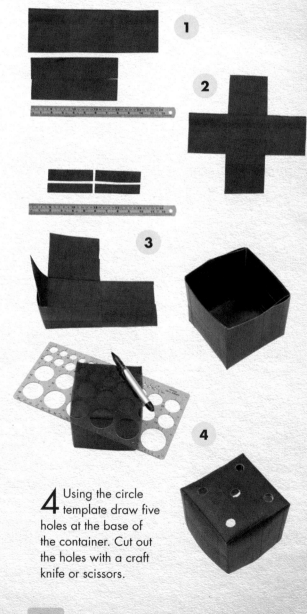

4 Using the circle template draw five holes at the base of the container. Cut out the holes with a craft knife or scissors.

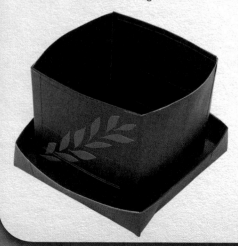

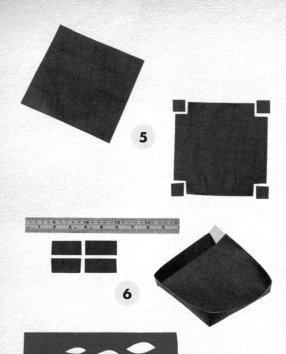

5

6

7

18. Any Occasion Napkin Rings

1 Cut a 5 in. (13 cm) strip of gold duct tape. Fold it lengthwise into thirds.

2 Pull the two ends together to form a circle and secure with a small piece of gold duct tape.

3 Repeat Steps 1 and 2 to make the number of rings required.

Materials

» Gold duct tape

1

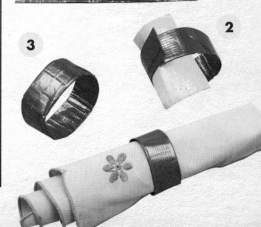

3

2

5 Make a double-sided fabric with the saddle leather duct tape measuring 7 in. (17.75 cm) square. Square up the sides. Remove a 1 in. (2.5 cm) square from each corner. Fold and unfold each outer edge 1 in. (2.5 cm) toward the center. This is the tray.

6 Cut a 4 in. (10 cm) strip of saddle leather duct tape. Cut in half lengthwise, and then cut again in half vertically to make four strips measuring approximately 2 in. (5 cm) by 1 in. (2.5 cm) high. Use these strips to close up the seams of the container at the outer edges of each wall.

7 Cut a 6 in. (15 cm) strip of lime green tape. Using a craft knife cut out leaves measuring 1 in. (2.5 cm) wide by ½ in. (1.25 cm) high. Arrange the leaves on one of the walls as a vine.

19. Lantern

Materials

» Wood grain duct tape
» 18-gauge plastic-coated steel wire
» Hanging light kit (can be found at home improvement stores)

Additional Tools

» Wire cutters
» Flat nose pliers

1 Cut a strip of wood grain duct tape measuring 36 in. (91.5 cm) long. Fold bottom edge over approximately ¼ in. (0.75 cm), as if you were starting to make a double-sided fabric. Then place a second 36 in. (91.5 cm) strip of tape on top, covering the sticky surface and slightly overlapping the folded edge of the first strip. Flip over from right to left and fold the top edge down. Repeat this step twice more to give three double-sided panels.

2 Cut a 36 in. (91.5 cm) strip of wood grain duct tape and cut it in half lengthwise.

3 Cut two 38 in. (96.5 cm) lengths of steel wire. Place one piece of wire along the center of one of the panels. Be sure it overlaps the fabric by 1 in. (2.5 cm) at each end. Cover the wire with one of the strips from Step 2. Repeat to give two wire-reinforced panels and one panel without any reinforcement.

4 Remove the cap on the bulb base of the lighting kit. Cut a 7 in. (17.75 cm) piece of steel wire. Bend it into a circle and wrap it around the bulb base. It should fit around the base securely when the cap is screwed on, but it shouldn't be snug or tight. Remove the wire ring from the base and twist the ends together to secure. This is the lantern base.

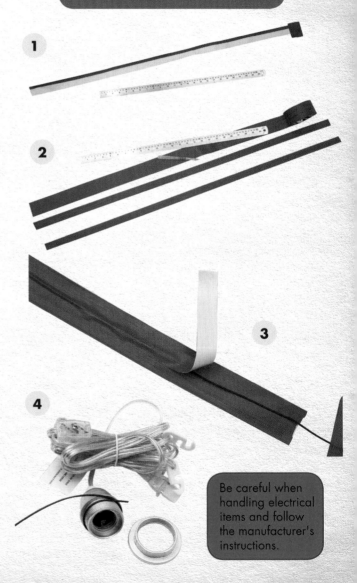

Be careful when handling electrical items and follow the manufacturer's instructions.

5 Take one of the wire reinforced panels. Secure one end to the 12 o'clock position on the lantern base and then gently curve it. Attach the other end to the 6 o'clock position on the lantern base. Repeat step on the second reinforced panel, securing it to the 3 and 9 o'clock positions on the lantern base. This is the body of the lantern. Cover any exposed wire on the lantern base with strips of wood grain duct tape.

6 Take the last panel and wrap it around the center of the lantern to form a loop and secure with a strip of tape.

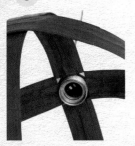

6

5

7 Adjust the lantern shape so it is round. Push the bulb base through the lantern base and screw on the cap. Secure the light kit to the ceiling with the hardware supplied with it. Add a light bulb and plug it in.

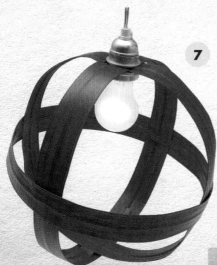

7

20. Shoe Mat

Materials

» Diamond plate duct tape
» Black duct tape
» Parchment paper

Additional Tools

» Shoe Print stencil on page 53
» Parchment paper

1 Make a double-sided fabric with the diamond plate duct tape measuring 28 in. (71 cm) wide x 18 in. (45.5 cm) high. Square up the sides.

2 Using the shoe print stencil and parchment paper, make two right feet and one left foot stickers from black duct tape. Place the shoe prints diagonally across the mat. Cut off any excess tape that extends over the mat's edges.

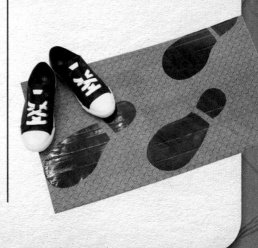

21. Hanging Room Partition

Materials

» White duct tape
» Electric blue duct tape
» Large paper clips
» Standard-size paper clips
» Screw hooks

Additional Tools

» ⅛ in. (3 mm) hole punch

1 Cut a 4 in. (10 cm) strip of blue duct tape and place it on your worktable with the sticky side facing up. Cut a 4 in. (10 cm) strip of white duct tape and place it squarely on top of the blue strip, sticky side facing down. Fold in half lengthwise and cut out a feather shape. Repeat twice more to make a total of three feathers. Using the hole punch, make a hole at the top and bottom of each feather. Set feathers aside.

2 Cut fourteen 1 ¼ in. (3 cm) wide strips of white duct tape.

3 Attach six large paper clips to each other in a chain. Attach a feather to the end of the chain by threading the clip into the top hole. Tightly wrap each paper clip with a strip of white duct tape.

4 Attach four large paper clips to the hole at the bottom of the feather to continue the chain. Attach a feather to the end of the chain. Tightly wrap each paper clip with a strip of white tape. Repeat to give a chain of fourteen covered paper clips and three feathers.

5 Cut fourteen ¾ in. (2 cm) wide strips of blue duct tape.

6 Attach fourteen standard-size paper clips to the top of the existing chain. Tightly wrap each clip with a strip of blue duct tape to complete one chain. Repeat Steps 1 to 6 until you have the desired number of chains. Use screw hooks to attach them to the doorway or ceiling, spacing them approximately 2 in. (5 cm) apart.

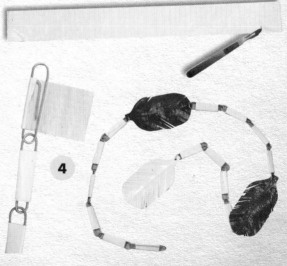

22. Sponge Dish

Materials

» White duct tape

Additional Tools

» Parchment paper

1 Make a double-sided fabric with the white duct tape measuring 8 in. (20.5 cm) wide by 6 in. (15 cm) high. Square up the sides. Remove a 1 in. (2.5 cm) square from each corner. Fold and unfold each outer edge 1 in. (2.5 cm) toward the center.

2 Cut a 3 in. (7.5 cm) strip of white tape. Cut in half lengthwise, and then cut in half vertically to give four strips measuring approximately 1 ½ in. (4 cm) wide by 1 in. (2.5 cm) high. Use these strips to close up the seams at the outer edges of each wall.

3 Cut two 4 in. (10 cm) strips of white tape. Fold them over the short walls of the sponge dish. Cut two 6 in. (15 cm) strips of white tape. Fold them over the long walls of the sponge dish.

23. Wall Umbrella Holder

Materials

» Black duct tape
» Newspaper print duct tape
» Two screw hooks

Additional Tools

» White grease pencil
» ¼ in. (0.75 cm) hole punch

1 Make a double-sided fabric with the black duct tape measuring 21 in. (53.5 cm) wide by 16 in. (40.5 cm) high. Square up the sides.

2 Cut a 17 in. (43 cm) strip of newspaper print duct tape and place it vertically on the worktable with the sticky side facing up. Place the left edge of the black fabric on top of the newspaper print strip, overlapping it by ¼ in. (0.75 cm). Then fold the strip in half vertically, pulling the left edge over the black fabric. Trim any excess newspaper print tape. Repeat on the right edge of the black fabric.

3 Fold the fabric in half vertically and rotate 90 degrees clockwise so the newspaper print is at the top edge.

4 At the left edge, pull back the top layer. Cut a 10 in. (25.5 cm) strip of black tape and place it vertically halfway on top of the left edge of the second layer. Fold the strip back in half so the sticky side is facing up. Replace the top layer of the fabric so that it is lying on top of the sticky strip. Press down to seal the edges together, closing the inside seam. Repeat on the right edge to make a pouch.

5 At the bottom-left corner, mark 1 in. (2.5 cm) in from the left with the white grease pencil. Grab the corner and pinch it from the left and bottom edge. This will flatten it in the opposite direction and raise the corner into a triangle. Pull the triangle down and in towards the bottom edge, and fold at the white pencil mark. Hold triangle in place with a small piece of black duct tape. Repeat at the bottom right corner. This will flatten out the bottom of the pouch. This is the umbrella holder.

1

2

3

4

5

6 Starting at the top of the left edge, cover the outer seam with a continuous strip of newspaper print duct tape, moving down and over the bottom of the holder, and up the outer seam of the right edge. Cut off excess tape at the top.

7 Cut two 6 in. (15 cm) strips of newspaper print duct tape. Place one strip in the middle of the top opening, sticky side facing up. Place the second strip squarely on top of the first strip, sticky side facing down.

8 Punch two holes on the back of the holder, each one approximately 1 ½ in. (4 cm) from the outer edge and 1 in. (2.5 cm) from the top edge. These are the hook holes. Secure the holder to the wall with the screw hooks. Add a decorative umbrella sticker to the front (see page 53).

8

6

7

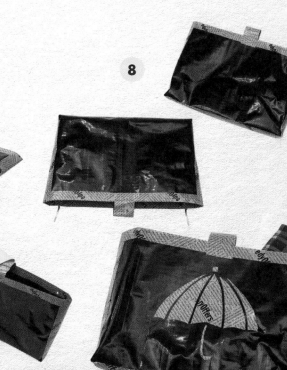

37

24. Dormitory Organizer

1 Make six double-sided fabric pieces from the denim duct tape measuring 6 in. (15 cm) wide by 8 in. (20.5 cm) high. Square up the sides. These are the backs of the pockets.

2 Make three double-sided fabric pieces from the transparent duct tape in a trapezoid shape measuring 7 ½ in. (19 cm) high, 6 in. (15 cm) wide at the base, and 10 in. (25.5 cm) wide at the top. Repeat this step with the leopard print duct tape. These are the fronts of the pockets.

3 Cut three 6 in. (15 cm) strips of leopard print duct tape and cut them in half lengthwise. Use these strips to attach the fronts to the backs of the pockets at the bottom and outer edges. Cut off excess tape at the corners. You should have six finished pockets.

4 Cut a 33 in. (84 cm) strip of leopard print duct tape and place it on the worktable with the sticky side facing up. Starting 4 in. (10 cm) from one end, place three of the pockets on top of the tape, aligning them along the left edges and spacing them approximately 1 ½ in. (4 cm) apart. Repeat step for the right edges of the pockets. Repeat for the remaining three pockets.

5 Attach the hanger to the top of the strips from the two top pockets by folding the strips over the bottom wire. You should have two hanging rows of pockets. Cut a 6 in. (15 cm) strip of leopard print duct tape and attach it to both center pockets so the rows hang straight down.

6 Cut strips of leopard print duct tape and place them squarely on any exposed sticky surfaces remaining from the strips holding the pockets in rows.

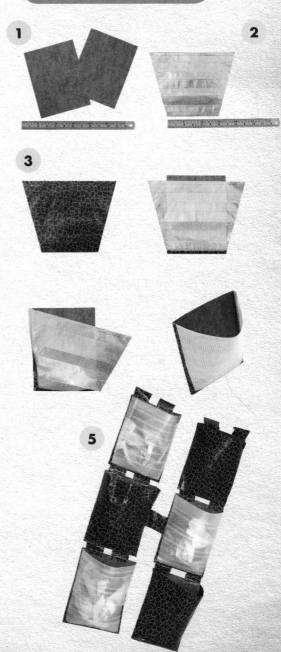

25. Take-Out Menu Folder

1 Take apart the cereal box by carefully undoing the glued seams with a finger or a pencil.

2 Place box on the worktable in the horizontal position, printed side facing down. Cut off the corners of the left and right outer panels. Begin to make the cut at the corner of the adjacent panel, cutting outward at a 45-degree angle.

3 Fold in the outer panels all around the box. Place three strips of tape (any color) vertically underneath the folded panel on each side, sticky side facing up, building a single-sided layered fabric ½ in. (1.25 cm) shorter than the front and back panels of the cereal box. This will hold the folded outer panels in place and form pockets on the left and right sides.

4 Place three strips of newsprint tape vertically over the pockets on each side, covering its sticky surface. Along the inner vertical edges of both pockets cut off the corners of the top and bottom folded edges at a 45-degree angle. This is the folder.

5 Flip the folder over from left to right. Cover left and right sides with basket weave duct tape, placing the strips vertically over the panels and extending past the edges by ½ in. (1.25 cm), but leave the middle bare. Fold the extra fabric over the edges.

6 Place two vertical strips of white linen tape over the middle of the folder. They should extend past the top and bottom edges by a few inches. Fold the excess tape over the edges.

7 Place two more vertical strips over the middle of the folder for reinforcement, this time shorter than the overall height of the folder.

Cushions, Pads, Mats, and Pillows

Duct tape pillows are, as you would expect, incredibly practical. Spilled liquids and unwanted dirt (is there any other kind?) wipe right off with a damp sponge, leaving your couch or chair cleaner than perhaps some other parts of the living room. But what is surprising is how cozy they are. The duct tape polar bear pillow that may sit in your favorite reading chair will ultimately find its way into the arms of any passerby, from a squealing 'tween to a formerly skeptical mother-in-law. I speak from experience.

Pillows, cushions, and mats also happen to be easy to make in relation to, let's say, a duct tape rain hat. Once you can master making larger double-sided layered fabrics, you can make a pillow in thirty minutes. This means if you are motivated enough, you can make seat cushions for every family member in a single afternoon—whether they want one or not!

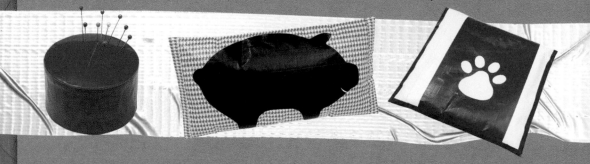

Materials

» Blue paisley duct tape
» Silver duct tape
» Pieces of cardboard, enough to make two layers each measuring at least 17 in. (43 cm) by 13 in. (33 cm)
» Fiberfill

26. Lap Cushion

1 Using small strips of silver duct tape, piece together the cardboard to make two layers each measuring at least 17 in. (43 cm) wide by 13 in. (33 cm) high. Cover the smoothest side with blue paisley duct tape, ensuring that the strips of tape are long enough to fold over the edges. This is the tabletop.

2 Make a double-sided layered fabric with the silver duct tape that is the same size as the tabletop. Square up the sides. Remove 1 in. (2.5 cm) squares from each corner. Pinch and tape each corner together with small pieces of silver tape. This is the cushion cover.

3 With strips of blue paisley duct tape, attach the cushion cover to the backside of the tabletop on three sides. Stuff the cushion cover with Fiberfill to the desired puffiness. Seal the last edge with a strip of blue paisley duct tape. Cut off excess tape.

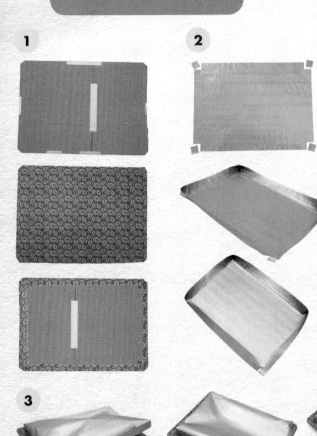

27. Stadium Seat Cushion

Materials

» White duct tape
» Ocean blue duct tape
» Dining chair cushion, 15 in. (38 cm) square and 3 ½ in. (9 cm) deep
» Two 3 in. (7.5 cm) strips of Velcro®

Additional Tools

» Paw Print stencil on page 51
» Parchment paper

1 Make two double-sided fabric pieces using the ocean blue duct tape, each measuring 22 in. (56 cm) by 20 in. (51 cm). Square up the sides. Set one aside. Using the white duct tape, add horizontal stripes to the top and bottom, each measuring 3 in. (7.5 cm) high.

2 Place the white striped fabric on top of the solid blue fabric, with the striped side facing up, so all the edges align. On one side, pull the top fabric back and place a strip of white duct tape halfway along the edge, sticky side facing down. Pull back the tape so that the unattached sticky surface faces up. Place the top fabric back on top of the bottom fabric to seal. Repeat on two other sides so that three seams are sealed.

3 Use strips of blue tape to close the outside of the three seams. Cut off excess tape.

4 Using the animal paw print stencil and parchment paper, make a sticker with white duct tape. Place it on the front of the cushion cover. Place the cushion inside the cover.

5 Cut four 6 in. (15 cm) strips of white duct tape. Measure 1 ½ in. (4 cm) inward from one end and mark it on each strip.

6 At the open edge of the cover, mark approximately 2 in. (5 cm) in from the corners. Place a strip of white tape at the 2 in. (5 cm) mark on the right side overlapping the open edge at the 1 ½ in. (4 cm) mark. Cover the reverse of the strip with another white strip to form a strap. Repeat on the left side so you have two straps attached to the open edge.

7 Remove the protective backing from the Velcro® strips and add them to the ends of each strap. Close the cover.

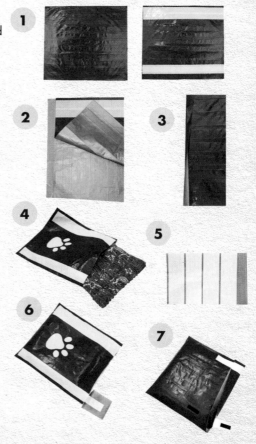

1

2 3

4

5

6

7

Materials

» Orange duct tape
» Black duct tape
» Newspaper print duct tape
» Fiberfill

28. Keyboard Wrist Pillow

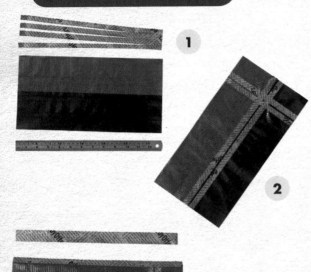

1 Make a double-sided layered fabric with the orange and black duct tape that measures 13 in. (33 cm) wide by 7 in. (17.75 cm) high. Square up the sides.

2 Cut a 13 in. (33 cm) strip of newspaper print duct tape. Then cut the strip lengthwise into four equal pieces. Arrange the strips on the fabric, two horizontally and two vertically.

3 Fold the fabric in half lengthwise. Cut a 13 in. (33 cm) strip of newspaper print duct tape and cut in half lengthwise. Close up the long side of the fabric with one of these strips. Move the fabric around so the newspaper stripes are on the front.

4 Cut the remaining strip in half vertically. Close up one side with one of these strips. Stuff the inside with Fiberfill to the desired puffiness. Close up the remaining open side with the last strip of newspaper print tape.

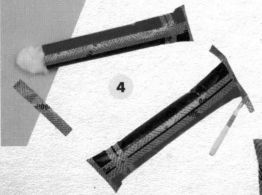
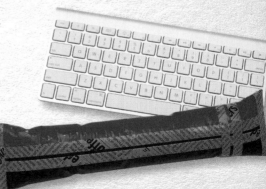

29. Book Pillow

Materials

» Saddle leather duct tape
» White duct tape
» Heart duct tape
» Fiberfill
» One 6 in. (15 cm) strip of Velcro®
» One 1 ¾ in. (4.5 cm) strip of Velcro®

1 Using the saddle leather and white duct tape make a double-sided fabric that measures 23 ½ in. (60 cm) wide by 11 in. (28 cm) high. The front of the fabric is saddle leather and the back white. Square up the sides.

2 With the white side facing up, make a mark 1 in. (2.5 cm) in from each side edge. Using the long metal ruler, vertically score and fold the fabric. Cut each of the four corners at a 45-degree angle. Refold the left and right sides and tape down with strips of heart duct tape. This is the cover of the book pillow.

3 Make a double-sided layered fabric with the heart duct tape that measures 21 ½ in. (54.5 cm) wide by 11 in. (28 cm) high. Square up the sides.

4 On three sides close up the outside seam with strips of heart tape. Cut off excess tape. Stuff with Fiberfill to create a pillow, then close up the remaining seam with a strip of heart tape. Remove the protective backing from the 6 in. (15 cm) strip of Velcro® and add it to the back of the pillow. Attach pillow to the inner right side of the cover.

5 Make a double-sided layered fabric with the heart tape that measures 8 in. (20.5 cm) wide by 5 in. (13 cm) high. Square up the sides. Remove 1 in. (2.5 cm) squares from the bottom two corners. Fold the left, right, and bottom edges 1 in. (2.5 cm) inward to form the pocket. Using strips of heart duct tape, attach the left, bottom, and right edges of the pocket to the inner left side of the cover. This is the complete book pillow.

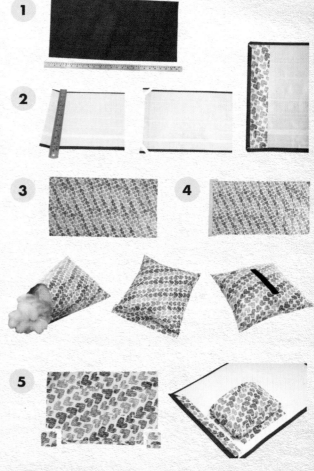

6 Cut a 7 in. (17.75 cm) strip of heart duct tape and place it on the worktable with the sticky side facing up. Cut a 5 ½ in. (14 cm) strip of heart duct tape and place it squarely on the 7 in. (17.75 cm) strip, sticky side facing down. There should be 1 ½ in. (4 cm) of the exposed sticky side remaining from the 7 in. (17.75 cm) strip. This is the cover strap.

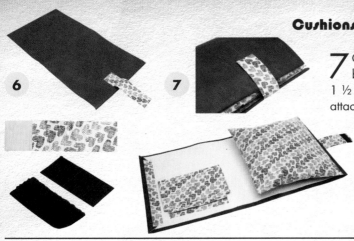

7 Close the book pillow so the backside is facing up. Use the 1 ½ in. (4 cm) exposed end to attach the cover strap to the center of the left edge. Remove the protective backing of the 1 ¾ in. (4.5 cm) Velcro® strip and place it on the end of the strap. Wrap the strap around the opening of the book pillow and attach it to the front.

Materials

» Pink houndstooth duct tape
» Black duct tape
» White duct tape
» Fiberfill

Additional Tools

» Pig stencil on page 51
» Parchment paper

30. Pig Pillow

1 Make a double-sided layered fabric with the pink houndstooth duct tape that measures 17 ½ in. (44.5 cm) square. Square up the sides. Fold down the fabric lengthwise and close up the bottom edge and the right edge with strips of houndstooth duct tape. This is the pillow cover.

2 Using the pig stencil, make a sticker with the black duct tape. Place the sticker on the front of the pillow cover. Cut a small crescent moon shape approximately 1 in. (2.5 cm) long from the white tape. This is the pig's mouth. Place it on top of the black pig sticker.

3 Fill the pillow with Fiberfill. Close up seam with a strip of houndstooth duct tape. Cut off excess tape.

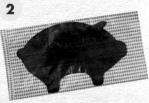
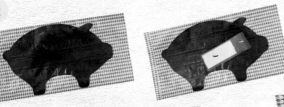

31. Pin Cushion

Materials

» Red duct tape
» Wood grain duct tape
» White duct tape
» Empty duct tape roll
» Cardboard from a cereal box
 or other dry food container
» Fiberfill

1 Place the empty duct tape roll on top of two white duct tape strips. From the inside of the roll, trace a circle onto the strips. Remove the tape roll and cut out the circle. Place it on the sticky side of a square of red duct tape.

2 Flip the square top over so the fabric and sticky side are facing up. Place the empty tape roll on top and cut the tape down around the outer part of the roll. Do not cut too close to the edge of the roll—leave some room so you can fold the tape over the edge. Fold the tape over the edge to secure it.

3 Place the roll on top of the cardboard. Trace around the outside of the roll. Remove the roll and cut out the circle of cardboard. Cover it with wood grain duct tape. Flip over and set aside.

4 Fill the inside of the roll with Fiberfill so that the red-tape-covered end puffs out. Quickly place the open end of the roll down on the cardboard circle and cut the wood grain tape around the outer part of the roll. Do not cut too close to the edge of the roll—leave some room so you can fold the tape over the edge. Fold the tape over the edge to secure it.

5 Cover the tape roll with wood grain tape.

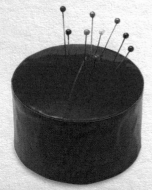

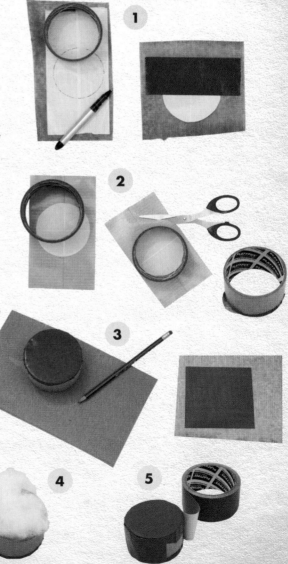

Materials

» Wavy duct tape
» Black duct tape
» 15 in. (38 cm) by 17 in. (43 cm) by 2 in. (5 cm) Fiberfill cushion

Additional Tools

» Parchment paper

32. Adirondack Chair Cushion

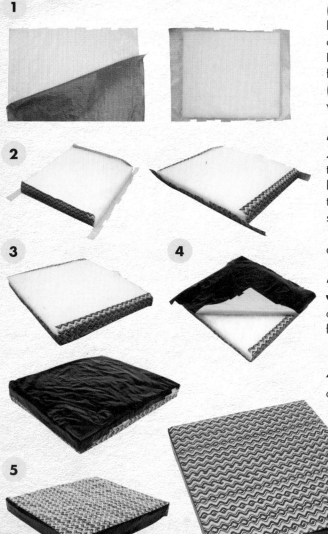

1 On top of a large piece of parchment paper, make a one-sided layered fabric with the wavy duct tape that measures 17 in. (43 cm) wide by 21 in. (53.5 cm) high. Flip over from left to right and carefully peel off the parchment paper. Place the cushion in the center of the fabric, making sure that the 15 in. (38 cm) side of the cushion aligns with the top and bottom of the fabric.

2 On the fabric, mark where it meets the bottom outer corners of the cushion. Cut vertical slits into the bottom edge of the fabric, then pull the bottom edge up so it covers the side of the cushion. Rotate the cushion 180 degrees so the top edge is now at the bottom and repeat step.

3 Fold the remaining edges of the fabric over so all the sides of the cushion are covered and wrap the flaps around the corners.

4 With the black tape, make a one-sided layered fabric directly on top of the remaining uncovered side of the cushion. Trim it down around the perimeter so it is approximately ½ in. (1.25 cm) larger all around the edges of the cushion. Fold it down.

5 Wrap a continuous piece of black tape around the edges of the cushion.

33. Polar Bear Pillow

Materials

» White duct tape
» Black duct tape
» Fiberfill

Additional Tools

» Polar bear pattern from website: www.richelafabianmorgan.com
» Parchment paper

1 Make two double-sided layered fabrics with white duct tape that each measure 23 in. (58.5 cm) wide by 12 in. (30 cm) high. Place them on top of each other. Then place the polar bear body pattern on top and trace it onto the top layer. Remove the pattern and cut through both layers.

2 Cut a 20 in. (51 cm) strip of white duct tape. Cut it in half lengthwise. Cut "X"s into the strips at 1 ½ in. (4 cm) intervals to make hexagon-shaped pieces. Use these pieces to seal the two layers together around the edge, leaving an opening. Fill the pillow with Fiberfill, then close up the hole with the remaining tape. This is the main body of the pillow.

3 Using the polar bear pattern, make a sticker for the head with white duct tape. Place the sticker on the top portion of the pillow, making sure the wider part of the head is at the bottom.

4 Using the pattern, make stickers with black duct tape for the eyes, nose, mouth, and chin. Place the eyes, nose, and mouth on the head. Place the chin right below the head.

5 Cut a 5 in. (13 cm) strip of white duct tape and place it on the worktable with the sticky side facing up. Cut a second 5 in. (13 cm) strip of white duct tape and place it squarely on the first strip, sticky side facing down. From this double-sided strip, cut out two triangles that measure 2 in. (5 cm) wide and 1 in. (2.5 cm) high for the ears. Attach to the top of the pillow with small pieces of white duct tape.

6 Using the pattern, make stickers with black and white duct tape for the paws. Place them on opposite sides of the pillow just beneath the head.

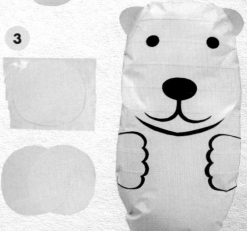

Materials

» Ocean blue duct tape
» Silver duct tape
» Cookie dough duct tape
» Lime green duct tape
» Diamond plate duct tape
» Black duct tape
» White duct tape
» Two pieces of Fiberfill quilt batting, each measuring 33 in. (84 cm) wide by 22 in. (56 cm) high.

34. Toddler Play Mat

1 Stack the pieces of quilt batting squarely on top of each other. Using the blue duct tape, make a one-sided layered fabric directly on top of the quilt batting that measures approximately 36 in. (91.5 cm) wide by 24 in. (61 cm) high. Flip over.

2 Using the silver duct tape, make a one-sided layered fabric directly on top of the quilt batting that measures approximately 36 in. (91.5 cm) wide by 24 in. (61 cm) high. Square up the sides. Flip over so the blue side is facing up. This is the play mat.

3 Using the various color duct tapes and parchment paper, create stickers to decorate the front of the mat: cookie dough for land, green for trees, black for roads, diamond plate for bridges, and white for traffic lines on the road.

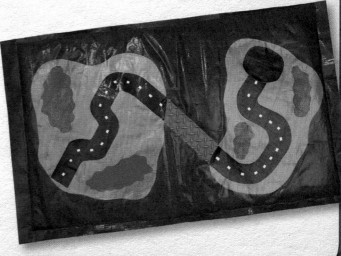

Decorative Stickers

Stickers made out of duct tape seem like a no-brainer. They're sticky on one side, colorful on the other, and you can use them to decorate items ranging from a toothbrush to a denim jacket. They can be tiny creatures that progressively take over a space, such as a mural filled with duct tape flower stickers. Or they can be a singular, oversized image that immediately grabs your attention, such as a peace symbol on a piece of luggage.

The trick to making duct tape stickers is using parchment paper. Once you have made a one-sided layered fabric on a piece of parchment paper, you can cut it into various shapes. When you are satisfied with your design, simply peel the parchment paper from the back and place the sticker on your desired surface.

Duct tape stickers are mini works of pop art, and anything can become your canvas. You don't have to possess artistic ability to make a stencil. You can use the stickers in this chapter, or try drawing simple images and letters onto cardboard. Go through newspapers and magazines for inspiration, and don't be afraid to trace something you like.

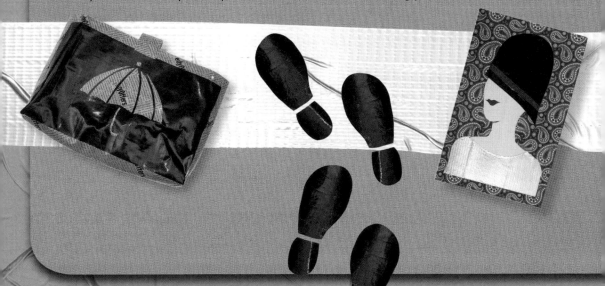

Instructions for all stencils

1 Create a paper stencil, either by copying, enlarging, and printing any of the stencils in this chapter, or by drawing it freehand. Set it aside.

2 Make a one-sided layered fabric on top of a sheet of parchment paper. Be sure it is large enough for the stencil to fit inside. Flip over so the parchment paper is facing up.

3 Place the paper stencil on top and trace it. If necessary, hold it in place with small strips of masking tape.

4 Cut out the shape with scissors or a craft knife. Carefully pull free the sticker shape from the fabric, making sure the parchment paper backing is intact. Discard all excess fabric, parchment paper, and masking tape.

35. Pig

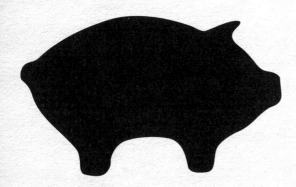

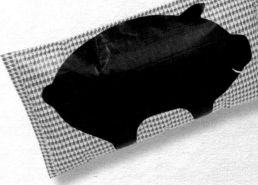

36. Paw Print

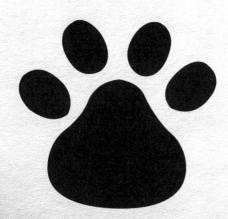

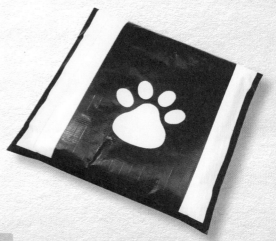

37. Handlebar Mustache and Bowler Hat

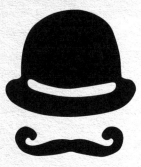

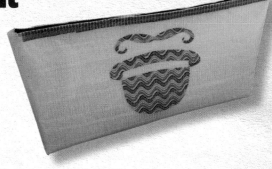

38. Art Deco Woman

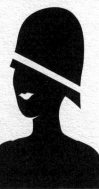

39. Zoot Suit Man

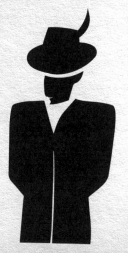

40. Shoe Print

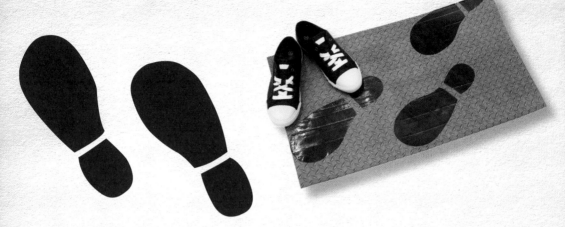

41. Umbrella

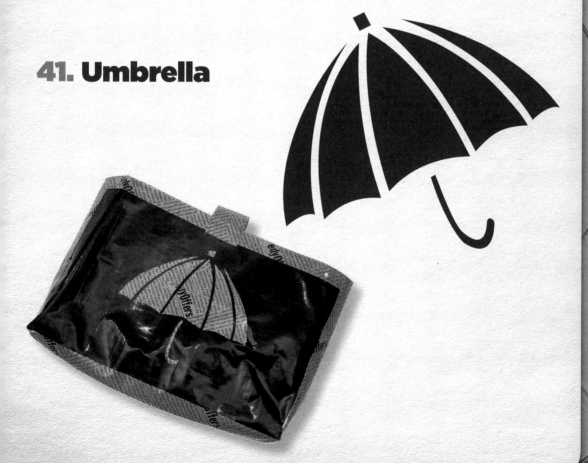

CHAPTER 5:

Bags and Cases

Someone recently asked me: what's your favorite duct tape project? Without any hesitation I said that it was a duct tape bag. Before duct tape came into my life, I had a closet full of clutches, wristlets, purses, totes, messenger bags, and briefcases, made from leather, velvet, or faux animal hide. Once I started making duct tape bags, my collection more than doubled. Each one is unique and fascinating.

To me, a bag is never "just" a bag. I take pride in constructing bags and I pore over details both big and small. There are so many variations to a bag that I begin the project by asking and answering some basic questions.

What are the occasions that the bag will be used for? Straps or no straps? How big and what shape? What kind of closure do I want? And what duct tape colors and/or patterns should I choose?

The coin purse, toiletry bag, and passport holder are the easy-level projects. There are online patterns available for many of the medium-level projects, while others may require the measurements of the items to be carried. The most challenging—and most rewarding—is the hobo bag. It's large enough to carry the load of a traditional hobo, but make no mistake about the style. This bag is sophisticated.

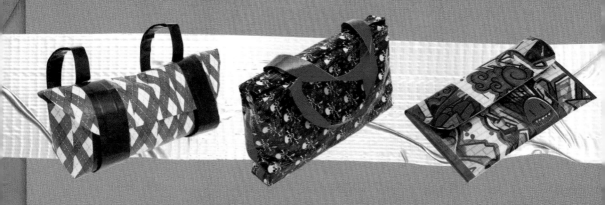

Materials

» Denim duct tape
» Blue and green plaid duct tape

42. Passport Holder

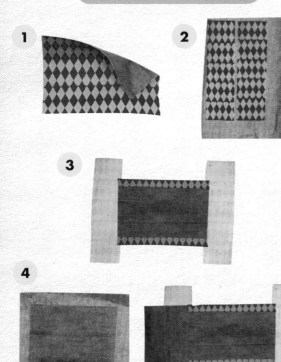

1 Make a double-sided layered fabric 7 ½ in. (19 cm) by 5 ½ in. (14 cm). The outside should be plaid duct tape and the inside denim. Square up the sides.

2 Make a single-sided layered fabric with the plaid duct tape 5 in. (13 cm) wide by 7 ½ in. (19 cm) high. Square up the sides, and then cut in half vertically. Place on the worktable with the sticky side facing up.

3 Position the fabric so the denim side is facing up and the top/bottom edges measure 7 ½ in. (19 cm) wide. Attach the two single-sided layered pieces from Step 2 to the left and right edges of the fabric, creating flaps. They should overlap the edges by ¼ in. (0.75 cm).

4 Make a single-sided layered fabric with denim duct tape 5 ⅛ in. (13.25 cm) wide by 4 in. (10 cm) high. Square up the sides. Rotate it 90 degrees and place it centrally on top of the left flap. The right edge should be flush to the main fabric and the left edge should overlap the flap by 1 ½ in. (4 cm).

5 Pull on the left edge and fold the left flap in and down. Fold over the excess tape at the top and bottom edges. This is the left pocket. Fold over the excess denim tape along the vertical edge of the pocket.

6 Repeat Steps 4 and 5 to create the right-hand pocket. Vertically fold the passport holder in half.

43. Hobo Bag

Materials

» Black duct tape
» Hot pink zebra duct tape
» Two pieces of cardboard, each 7 ½ in. (19 cm) wide x 1 ½ in. (4 cm) high
» 1 magnetic snap closure (top, bottom, and two washers)

Additional Tools

» Mini clamps or binder clips

1 Make two double-sided layered fabrics 12 in. (30 cm) by 20 in. (51 cm) with one side hot pink zebra duct tape and the other black. Square up the sides, turn 90 degrees, and set one aside.

2 Cut a 21 in. (53.5 cm) strip of black duct tape and lay it horizontally, sticky side up. Fold in bottom edge ¼ in. (0.75 cm). Flip strip left to right, sticky side down with folded edge along bottom. Place strip horizontally halfway on top edge of fabric and fold over. Repeat on other fabric.

3 Place both fabrics on the worktable, zebra side up. Align bottom edges and attach the fabrics by placing a strip of black tape over the seam.

4 Make two double-sided layered fabrics with hot pink zebra duct tape, each 5 ½ in. (14 cm) by 6 in. (15 cm). These are inside pockets. Vertically position pockets adjacent to each other on the top half of the bag. Attach pockets with strips of tape along the left, bottom, and right edges.

5 Make a double-sided layered fabric with the hot pink zebra duct tape 13 in. (33 cm) by 9 ½ in. (24 cm). Add strips of black tape to the top and bottom edges. Square up the sides. Fold in half horizontally. This is the inside pocket.

6 Starting at the top left corner of the bag fabric, place a 12 in. (30 cm) strip of black duct tape vertically halfway along the left outer edge. Vertically pull back the strip from the left edge towards the center. Place the left edge of the inside middle pocket 2 in. (5 cm) from the top of the tape strip. Repeat on right side and use the same method to attach inside pocket.

7 Along the bottom edge of the bag measure 2 in. (5 cm) in from the left corner. Place one finger on the left edge and bottom edge, then pinch to form a triangle at the left corner. Pull the tip of

6

7

the triangle in toward the bottom of the bag, and fold over at the 2 in. (5 cm) mark. Secure the triangle with a small piece of tape. Repeat step on the right side.

8 Cut two 19 in. (48 cm) strips of black duct tape and place them horizontally on the worktable, sticky side up. Fold over the top and bottom edges ¼ in. (0.75 cm). Use these two strips to cover the outside seam. Fold excess tape over the top edge.

9 Cut two 34 in. (86 cm) strips of black duct tape and place them horizontally, sticky side up. Fold in half horizontally, sticky sides together and again along the width to form a "V". These are the straps. Mark 12 in. (30 cm) on each strap.

8

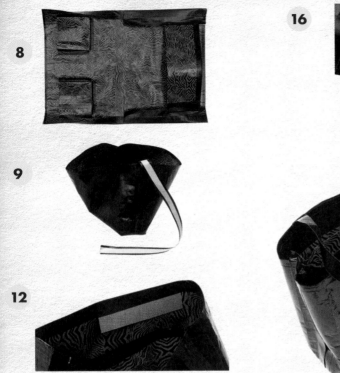

16

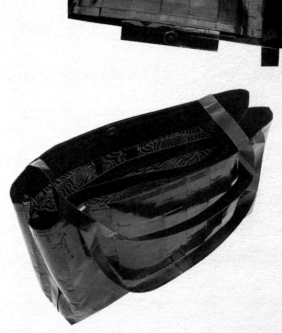

9

12

10 Close the top of the bag by placing clamps on the left and right sides. Mark 2 ½ in. (6.5 cm) in from the left and right top corners on the front panel. Repeat on the back.

11 With each bag strap, line up the marks and attach with a 5 in. (13 cm) strip of hot pink zebra duct tape inside the panels.

12 Take the cardboard and place it in the top center of the inside front panel. Cover with a strip of black duct tape. Repeat with the other cardboard on the back panel of the bag.

13 Cut four 1 in. (2.5 cm) square pieces of black tape and use to secure the straps at the four points on the outside front and back panels where the straps attach. Cut two 7 in. (17.75 cm) strips of black duct tape. Wrap one strip around each handle for support.

14 Make a black duct tape double-sided layered fabric 5 in. (13 cm) by 2 ½ in. (6.5 cm). Square up the sides. This is the flap.

15 With a strip of black duct tape, attach the back of the flap to the center of the inside back panel just below the border. Cut a strip of hot pink zebra duct tape 5 in. (13 cm) by ½ in. (1.25 cm). Vertically place this halfway on the front and halfway on the back panel border.

16 Take top part of magnetic closure and center on the flap. Push prongs down to mark position and remove. Cut the holes with a craft knife and push the prongs through. Flip flap over and push prongs through the washer, and fold prongs down to secure washer in place. Cover with a square of black duct tape. Repeat with bottom part of the magnetic closure and cover with hot pink zebra duct tape.

44. Fanny Pack

1 Make a double-sided fabric with houndstooth on one side (front), and white on the other (back), 20 in. (56 cm) by 23 in. (58.5 cm). Trace pattern onto white side and cut out.

2 Rotate fabric so front and back panels are at outer edges and bottom panel is vertically aligned center. With a ruler, score left and right vertical edges of back panel.

3 Cut two 1 ½ in. (4 cm) by ½ in. (1.25 cm) pieces of white duct tape and use to attach "C" sides together. Cut two 2 ¼ in. (5.75 cm) by ½ in. (1.25 cm) pieces to attach "B" sides together. Cut two 2 in. (5 cm) by ½ in. (1.25 cm) pieces to attach "A" sides together.

4 On the front of the front panel cut a 6 in. (15 cm) horizontal slit 1 in. (2.5 cm) from the top edge. Cut a 6 in. (15 cm) by 1 in. (2.5 cm) strip of white duct tape and place horizontally along the top edge of the slit, overlapping by ¼ in. (0.75 cm). Fold strip horizontally in half, creating a ¼ in. (0.75 cm) flap over the slit.

5 Using a ruler, score tabs at the top of the back panel. Cut ½ in. (1.25 cm) strips of white duct tape and attach the tabs to the top of the front panel from the inside of the fanny pack.

6 Cut one ¼ in. (0.75 cm) strip of white duct tape, and use to close the outside seams.

7 Cut a 30 in. (76 cm) strip of houndstooth. Attach one end to the back of the left side of the fanny pack, overlapping by 1 in. (2.5 cm). Repeat on front. Place the rest of the second strip directly on the first strip and repeat on right side for belt.

8 Cut a 4 ¼ in. (11 cm) by 1 in. (2.5 cm) strip of houndstooth. Fold horizontally into thirds, and connect ends with white tape for a loop.

Materials

» Black and white houndstooth duct tape
» White duct tape
» One Velcro® strip, 5 ¾ in. (14.5 cm) by ¼ in. (0.75 cm)
» One Velcro® strip, 10 in. (25.5 cm)

Additional Tools

» Pattern from website: www.richelafabianmorgan.com

9 Push belt arms through the belt loop. Fold over and secure in place with houndstooth. Attach Velcro® strip to belt and opening.

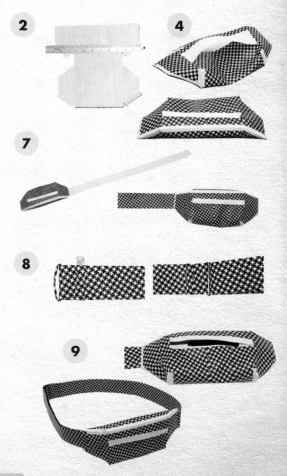

45. Bike Pouch

1 Using pink argyle, make a double-sided fabric 16 ½ in. (42 cm) by 14 in. (35.5 cm).

2 Pull up bottom edge and fold over at 6 in. (15 cm). Close up left and right edges with strips of 6 in. (15 cm) by 1 in. (2.5 cm) pink argyle. Mark 1 ½ in. (4 cm) in on bottom edge.

3 Pinch left and bottom edge to form a triangle at the left corner. Pull triangle down and fold at the 1 ½ in. (4 cm) mark. Hold in place with pink argyle. Repeat on right side. The piece at the top is the flap. Cut its corners to round.

4 Cut four 22 in. (56 cm) strips of black. Fold each horizontally in half. Set two aside. Cut two more strips, take folded strips and place in the center of each unfolded strip to make straps.

5 Open flap. On front panel, along top edge, mark 2 ½ in. (6.5 cm) from left corner. Take one of the straps and align left edge of one end to the mark. Press strap down and wrap it vertically around the pouch so the opposite end of the strap comes down the front. Repeat on right side.

6 Cover extending pieces of the straps with black. Overlap top edge of the flap by ¼ in. (0.75 cm). Trim straps so they are even.

7 Flip pouch over so front of back panel faces up. Along center portion of left black strap, mark two 1 in. (2.5 cm) lines parallel and 2 ½ in. (6.5 cm) apart. Repeat on right side.

8 Cut slits at the marked lines. Take one of the folded strips from Step 4 and push one end through the top left slit. Then pull the same end through the bottom left slit. Pull the strip through each slit equally. Repeat on right side.

Materials

» Pink argyle duct tape
» Black duct tape
» Two Velcro® strips, 3 in. (7.5 cm)
» Two Velcro® strips, 6 in. (15 cm) by ¼ in. (0.75 cm)

9 From inside of the pouch, secure handlebar straps to the back of the pouch.

10 Attach the shorter strips of Velcro® to the extending ends of the closure straps and the longer strips of Velcro® to the ends of the handlebar straps.

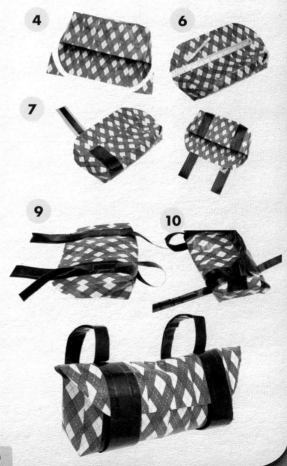

46. Tablet Case

Materials

» Blue chevron duct tape
» Orange linen duct tape

1 Measure width and height of your tablet in portrait position. Create two double-sided layered fabrics, ½ in. (1.25 cm) wider and 2 in. (5 cm) longer than the tablet. Use blue chevron duct tape for outside and orange linen duct tape for inside. Square up sides. Place tablet on top of one and set aside the other.

2 Take strip of blue the same width as the fabrics in Step 1. Fold over bottom edge. Add a second piece of blue, overlapping top edge of the first by ⅛ in. (3 mm). Square sides. Repeat so you have two pieces. Attach one along top edge of tablet fabric like a hinge. Repeat with bottom edge. Trim so they only add 1 in. (2.5 cm).

3 Fold down top and bottom pieces. Cut strip of orange 2 in. (5 cm) shorter than tablet fabric. Place strip sticky side up. Fold bottom edge up, leaving ¼ in. (0.75 cm) sticky surface exposed. Attach to right side.

4 Cut strip of orange 2 in. (5 cm) longer than tablet fabric. While three sides of tablet frame are folded down, place strip directly on right frame piece to align with outer left edge and cover the corners. Cut slits into top and bottom sections of the strip so it is flush with the edges. Fold strip over and trim.

5 Cut strip of blue 1 in. (2.5 cm) shorter than tablet fabric. Place ruler on left edge of tablet fabric, holding top and bottom pieces down. Slide blue strip, sticky side up, between tablet fabric and top and bottom frame pieces ¾ in. (2 cm) from edge.

6 Fold over blue strip. Remove ruler. Cut 1⁄16 in. (1.5 mm) slits at top and bottom left inside corners and fold right edge of blue tape down and inward. The frame is complete.

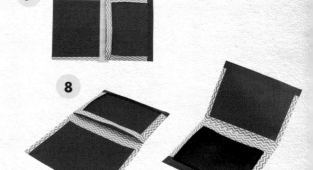

7 Remove tablet from frame. Cut strip of orange 1 in. (2.5 cm) longer than tablet fabric. Place vertically on worktable, sticky side up. Place tablet frame on right edge of strip, overlapping ½ in. (1.25 cm). Take remaining tablet fabric and place on left edge of the strip, leaving 1 in. (2.5 cm) between itself and the frame. Cut off excess tape.

8 Cut strip of blue exact length of the tablet fabric. Place over spine, matching up edges.

9 Cut strip of orange exact length of tablet fabric. Place vertically halfway over left edge of the cover. Fold down. Trim excess.

47. **Woven Gym Sack**

Materials

» Orange duct tape
» Black duct tape
» White duct tape

1 Make two double-sided fabrics 14 in. (35.5 cm) by 20 in. (51 cm), one black and one orange. Square the sides. Cut in half diagonally to make four triangles.

2 Switch one orange triangle with one black to create two sets of black and orange triangles. Cut two 25 in. (63.5 cm) strips of white duct tape and cut lengthwise. Use these to join each set of triangles along the diagonal.

3 Cut a 14 in. (35.5 cm) strip of white and use to attach fabrics together along shorter side. Fold horizontally along closed seam. This is the body of the sack.

4 Cut 20 in. (51 cm) strip of white. Pull back left edge of the sack's top layer. Place strip vertically halfway on top of left edge of bottom layer. Pull back strip from left edge so it is vertically in half and sticky side faces up. Place top layer back on bottom layer, closing left seam. Repeat to close right seam.

5 Cut 20 in. (51 cm) strip of black and cut in half lengthwise. Use strips to cover outside of left and right seams. Trim off excess.

6 Cut 36 in. (91.5 cm) strip of black and cut in half lengthwise. Take one half and fold it in three lengthwise. Take second piece and place it sticky side up on worktable. Place one end of the first piece ½ in. (1.25 cm) on top of second piece, ½ in. (1.25 cm) from outer edge. Fold second piece in three and right over the first, connecting pieces together. Tape loose ends and tie in a single knot. This is one pull string. Repeat to make a second. Loop strings around sack top, knotted ends at the bottom.

7 Cut two 13 in. (33 cm) strips of black. Lay one on the other, sticky side down, along long edge and overlapping by ½ in. (1.25 cm).

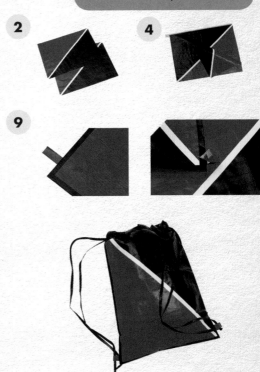

Flip strip over so sticky side faces up. Place strip of white duct tape down center. This is the pull loop.

8 Attach one end of the pull loop to the inside top edge of the sack's front panel. Push the two strings on the front panel up on top of the white part of the loop. Fold it over the strings and attach sticky area of loop to outside front panel. Flip sack over from left to right and repeat.

9 Cut 2 ½ in. (6.5 cm) strip of orange and fold in half. With a small piece of black, attach one end to bottom left corner of sack. Loop open end through pull string on the left side, then attach to bottom left corner with black tape. Repeat to attach the right pull string to bottom right corner.

48. Toiletry Bag

1 Make double-sided layered fabric using wavy green duct tape large enough to cut out the bowler hat and mustache. Set aside.

2 Using the transparent duct tape, create a single-sided layered fabric on top of the parchment paper 13 in. (33 cm) by 16 in. (40.5 cm). Flip fabric from left to right. Remove parchment paper. Place hat and mustache in center of bottom portion of the fabric. Cover fabric with another layer of transparent tape. Square up the sides.

3 Fold fabric in half horizontally. Cut 8 in. (20.5 cm) strip of transparent duct tape, and cut it in half lengthwise. Lift top layer on left side of folded fabric, and place one strip vertically halfway on the bottom layer's left edge. Pull back tape in half so sticky side faces up. Place top layer back on the bottom layer to attach edges. Lift top layer on right side of folded fabric and place remaining strip vertically halfway on the bottom layer's right edge. Pull back tape in half so sticky side faces up. Place top layer back on bottom layer to attach edges. This is the bag.

4 Cut 9 in. (23 cm) strip of transparent duct tape, then cut in half lengthwise. Take one strip and cover outer seam on left side of the bag. Repeat on the right side with remaining strip. Fold excess tape over top edge of the bag. Leave the excess pieces at the bottom corners.

5 At the left corner, pinch from the left edge and bottom edge to form a triangle. Pull the triangle down toward the bottom and fold inward ½ in. (1.25 cm). Hold in place with the remaining excess tape from the left side seam. Repeat on the right side.

6 Place the Velcro® strip on the inside of the bag opening.

Materials
» Wavy green duct tape
» Transparent duct tape
» One Velcro® strip 12 in. (30 cm) by ½ in. (1.25 cm)

Additional Tools
» Handlebar Mustache and Bowler Hat stencil on page 52
» Parchment paper

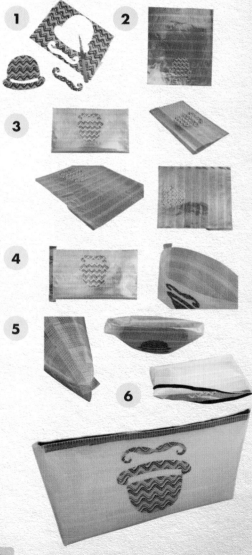

Materials

» Graffiti duct tape
» Black duct tape
» Orange duct tape
» One piece of cardboard, 3 ½ in. (9 cm) by 1 in. (2.5 cm)
» One Velcro® strip, 3 in. (7.5 cm) by ½ in. (1.25 cm)

49. Coin Purse

1 Make a double-sided layered fabric 4 ½ in. (11.5 cm) wide by 7 in. (17.75 cm) high. Use graffiti duct tape for the outside and black duct tape for the inside. Square up the sides.

2 Flip over from left to right so the black side is facing up. Pull up the bottom edge and fold over at the 5 ¾ in. (14.5 cm) mark. Close up the left and right edges with strips of orange duct tape 5 ¾ in. (14.5 cm) by ½ in. (1.25 cm).

3 Trim off the corners of the flap, rounding the edges. Place the cardboard on the center of the inside of the flap, the top edges nearly flush. Cover with a strip of black duct tape.

4 Place the Velcro® strip on the inside of the flap.

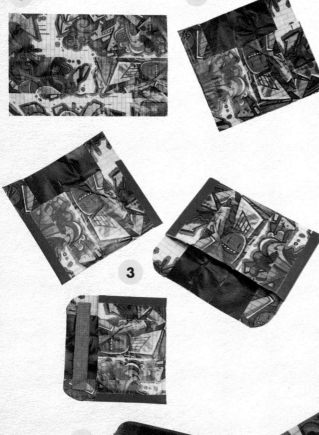

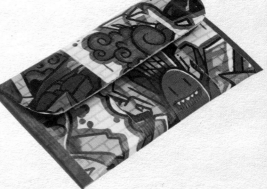

50. Beach Bag

Materials

» Blue and purple leopard print duct tape
» White duct tape

1 Cut fourteen 24 in. (61 cm) strips of leopard print duct tape. Fold each of them in half lengthwise and cut along the fold to make twenty-eight strips.

2 Divide the strips into pairs. Using ½ in. (1.25 cm) wide strips of white duct tape, connect each pair 1 ½ in. (4 cm) from the ends. This is the 1-2, 1-2 pattern.

3 Lay the paired-up strips on their sides. Connect the pairs to each other by wrapping ½ in. (1.25 cm) wide strips of white duct tape around the opposing strips 1 ½ in. (4 cm) below the 1-2, 1-2 pattern. This is the 2-1, 2-1 pattern.

4 Connect the strips every 1 ½ in. (4 cm), alternating the 1-2, 1-2 and 2-1, 2-1 patterns, until you reach the end of each strip. This is the netted fabric for the bag.

5 Use ½ in. (1.25 cm) wide strips of white tape to attach the left and right edges of the netted fabric. The pattern of the net will allow the edges to join in regular places so that you can complete the alternating pattern of the netting.

6 Extend the netted fabric to create two openings. To close one opening, bunch up the ends of the strips in one hand and tightly wind a strip of white tape around the ends twice.

7 At the open end, bend and tape down the protruding ends with ½ in. (1.25 cm) strips of white tape. The bag is complete.

8 Cut a 30 in. (76 cm) strip of white tape and fold it in three lengthwise. This is the shoulder strap. Attach to the opening of the bag with strips of white duct tape.

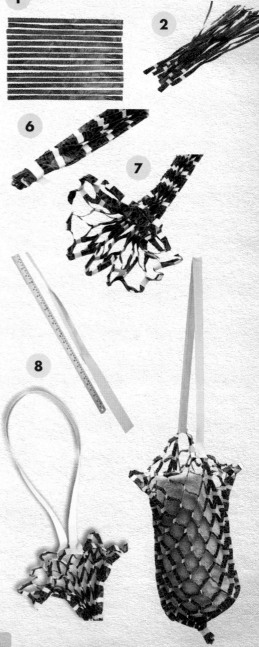

51. Portable Roll-Up Tote

Materials

» Blue and white floral duct tape
» White duct tape

1 Make two double-sided layered fabrics, 18 ½ in. (47 cm) wide by 16 ½ in. (42 cm) high. Use blue and white floral duct tape for the inside of each fabric, and blue and white floral duct tape with a white horizontal stripe 3 in. (7.5 cm) deep for the outside. Square up sides.

2 Position the fabrics so the inside is facing up and they are touching along the 18 ½ in. (47 cm) edges. Attach the fabrics by placing a strip of white duct tape over the touching edges. This is the bottom seam of the bag.

3 Place a 16 in. (40.5 cm) strip of white tape vertically halfway along the left edge of the top fabric. Pull back the strip from the left edge so that it is vertically in half and the sticky side is facing up. Pull up the bottom fabric and fold it at the bottom layer seam. Carefully place the left edge on top of the folded back tape and close up the left seam. Repeat step to close the right seam of the bag.

4 Cover the left, right, and bottom outer seams with ½ in. (1.25 cm) wide strips of white duct tape.

5 Cut two 24 in. (61 cm) strips of white duct tape. Fold them in half lengthwise. These are the shoulder straps. Measure and mark 1 in. (2.5 cm) from the ends of each strap.

6 Measure and mark 3 in. (7.5 cm) in from the left and right corners at the top edges of the front and back panels of the bag.

7 Take one strap and align the 1 in. (2.5 cm) mark on the ends to the 3 in. (7.5 cm) mark on the top edge of the front panel. Secure the strap to the inside of the front panel with strips of blue and white floral tape. Repeat to secure the remaining strap to the back panel. The tote is complete.

8 Fold the tote vertically in half. The straps should align with each other. Roll up from the bottom edge and wrap the straps around the center.

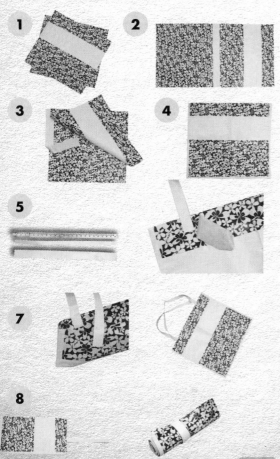

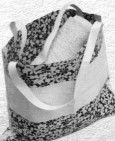

52. "Go" Bag

1 Using the skull and crossbones duct tape, make two double-sided layered fabrics 22 in. (56 cm) wide by 14 in. (35.5 cm) tall.

2 Remove a 1 ½ in. (4 cm) square from each corner of both fabrics to create four 1 ½ in. (4 cm) flaps at each side. Use the edge of a metal ruler to score the flaps.

3 Pull in at the corners so the edges of the flaps touch and form right angles. Secure using strips of skull and crossbones duct tape.

4 Join the pieces together along the long edge from the inside using a strip of black 19 in. (48 cm) long. This is the main body of the bag.

5 Using white duct tape, make two double-sided layered fabrics 8 in. (20.5 cm) square. Square up the sides. Remove 1 in. (2.5 cm) squares from the bottom left and right corners.

6 Score and fold the flaps on the left, bottom, and right sides. Pull in at the corners so the edges of the flaps touch and form right angles. Secure using strips of white. These are pockets.

7 Attach pockets to the inside back panel of the bag, at the left, bottom, and right sides using strips of white, making sure the pocket openings face the top of the bag.

8 Using the white duct tape make a double-sided layered fabric 16 in. (40.5 cm) wide by 6 in. (15 cm) high. Square the sides. Remove 1 in. (2.5 cm) squares from bottom corners.

9 Score and fold the flaps on the left, bottom, and right sides. Pull in at the corners so the edges of the flaps touch and form right angles. Secure using strips of white. This is the long pocket.

Materials

» Skull and crossbones duct tape
» Black duct tape
» White duct tape
» Lime green duct tape
» One piece of cardboard, 18 ½ in. (47 cm) by 1 ½ in. (4 cm)
» 2 pieces of cardboard, 6 ½ in. (16.5 cm) by 1 in. (2.5 cm)
» One strip of Velcro®, 18 in. (45.5 cm)

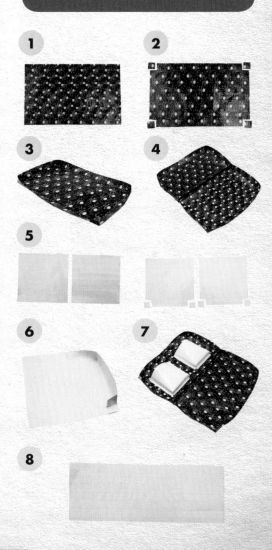

1

2

3

4

5

6

7

8

10 Attach the pocket to the inside back panel of the bag, at the left, bottom, and right sides using strips of white, making sure the pocket opening faces the top of the bag.

11 Place the large piece of cardboard onto the worktable. Cover with lime green tape. Place the cardboard/tape strip along the outside bottom of the bag. Cut off excess tape.

12 Cut a 24 in. (61 cm) strip of lime green. Place on worktable, sticky side up. Cut a

second 24 in. (61 cm) strip of green. Place on first strip. Repeat this step for handles.

13 Measure 3 in. (7.5 cm) along top edge of front of bag from left corner. Mark it, then cut a 2 in. (5 cm) slit. Repeat on right side. Repeat on back panel.

14 Take one of the handles and push 1 ½ in. (4 cm) of one end through left slit on front panel. Then push other end through right slit. Secure handle ends to the inside with strips of black. Repeat to secure the second handle to the back panel. Secure the handles to the outside of the bag with strips of skull tape at the base of each handle.

15 Cover bottom seam with ½ in. (1.25 cm) strips of lime green and close up side seams in the same way, leaving 2 in. (5 cm) open at the top on each side.

16 Place the two 1 in. (2.5 cm) wide pieces of cardboard on top of strips of black tape. Tape cardboard to the inside of the front and back top flaps between the handles.

17 Cut a 19 in. (48 cm) strip of skull and crossbones tape. Place onto top edge of the front panel so it overlaps by ¼ in. (0.75 cm). Fold in half lengthwise. This is the extended front flap.

18 Add the strip of Velcro® to the inside of the front flap.

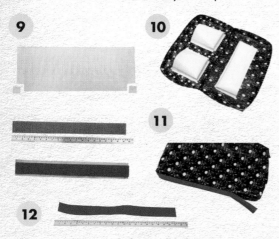

9

10

11

12

13

14

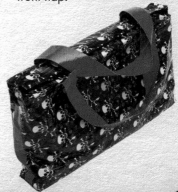

15

16

18

53. Tool Bag

Materials

» Silver duct tape (3 in. (7.5 cm) wide if possible)
» Diamond plate duct tape
» Black duct tape
» Two pieces of cardboard, 5 in. (13 cm) wide by 1 ½ in. (4 cm) high

1 Using the silver duct tape, make a double-sided layered fabric 22 ½ in. (57 cm) wide by 22 in. (56 cm) high. Square up the sides.

2 Fold and unfold the fabric in half horizontally. Place an 11 in. (28 cm) strip of silver duct tape halfway along the left edge. Make sure the top of the strip is flush against the top edge of the fabric. Pull back the strip from the left edge so that it is in half vertically and the sticky side is facing up. Refold the fabric in half. Carefully place the left edge on top of the folded-back tape and close up the left seam. Repeat for the right seam. This is the main pocket of the tool bag.

3 Measure and mark 2 ½ in. (6.5 cm) from the left and right corners along the bottom edge. Pinch from the left edge and bottom edge to form a triangle at the left corner. Pull the triangle down toward the bottom and fold at the 2 ½ in. (6.5 cm) mark. Secure with a small piece of silver duct tape. Repeat on the right side.

4 Cut a 15 in. (38 cm) strip of diamond plate duct tape. Place it on the worktable with the sticky side facing up. Cut four 1 ½ in. (4 cm) strips of black duct tape. Place the black strips directly on top of the diamond plate strip, leaving a 1 in. (2.5 cm) space in between. Place diamond plate strip onto the outside front panel of the tool bag 1 ½ in. (4 cm) from the top edge. Pull the sections with black tape outward to form tool loops.

5 Repeat Step 4 for the outside back panel.

6 Cover the outside seam with a strip of black duct tape, starting at the top left corner, going down the left side, around the bottom, up the right side, and stopping at the right corner.

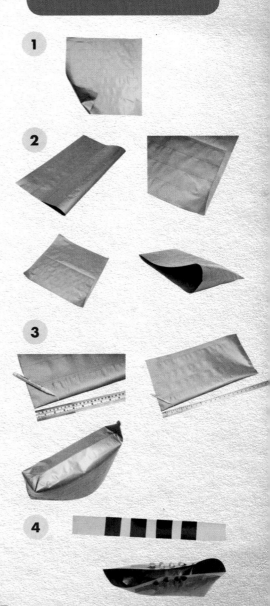

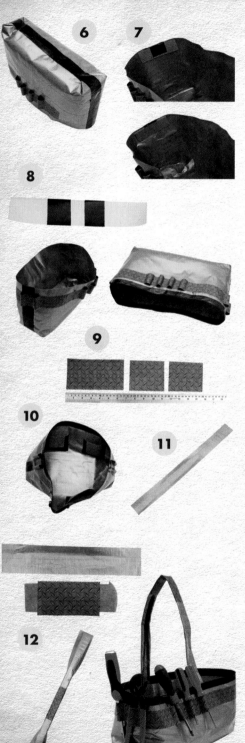

7 Take one piece of cardboard and place it along the inside short edge of the bag, flush against the top edge. Hold in place with a small piece of black duct tape. Repeat on the opposite side with the remaining piece of cardboard. Cover cardboard with silver duct tape.

8 Cut a 9 ½ in. (24 cm) strip of diamond plate duct tape. Place it on the worktable with the sticky side facing up. Cut two 1 ½ in. (4 cm) strips of black duct tape. Place the black strips directly on top of the diamond plate strip, leaving a 1 in. (2.5 cm) space in between. Place the diamond plate strip onto the outside side panel of the tool bag 1 ½ in. (4 cm) from the top edge. Be sure to pull the sections with black tape outward to form tool loops. Repeat on the opposite side.

9 Make three double-sided layered fabric pieces, one 6 ½ in. (16.5 cm) wide by 3 ½ in. (9 cm) high, and two 4 in. (10 cm) wide by 3 ½ in. (9 cm) high. Square up the sides. These are the inside pockets.

10 Attach the left, right, and bottom edges of each pocket to the inside panels of the tool bag using strips of black duct tape ½ in. (1.25 cm) wide.

11 Cut a 30 in. (76 cm) strip of silver duct tape. Place it on the worktable with the sticky side facing up. Cut a second 30 in. (76 cm) strip of silver duct tape and place it squarely on top of the first strip. This is the tool bag handle.

12 Using the diamond plate duct tape, make a single-sided layered fabric 6 ½ in. (16.5 cm) wide by 3 ½ in. (9 cm) high. Square up the sides. Make a triple fold in the center of the tool bag handle and wrap the diamond plate fabric around it to secure it.

13 Make a triple fold in the rest of the tool bag handle and secure with ¼ in. (0.75 cm) wide strips of black duct tape. Attach the handle to the inside front and back panels of the bag with strips of diamond plate duct tape.

Flowers, Fruit, and Plants

A few years ago my sister Elle gathered us at her house for a family dinner. Knowing that my family is rarely punctual, my kids and I arrived thirty minutes late and partially sated by snacks eaten during the car ride. My parents arrived an hour after me—and they were ready to eat. The only problem was that my sister anticipated even more late arrivals and wasn't quite ready to serve dinner. My dad began foraging around the house for food and came upon a large bowl of shiny fruit, grabbed what he thought was a Bartlett pear, and voraciously bit into it. I heard his yelp from the kitchen; he had chomped into a piece of plastic fruit! My sister scolded him for ruining her

centerpiece while the rest of us laughed. And I walked away inspired to make fake fruit and other foliage. (Thanks, Dad!)

In this chapter there are two fruit projects: an orange and a banana. I've made a whole basket of oranges but no one has ever mistaken them for the real thing, including my dad. They are fairly easy to make and the templates allow you to make them over and over again.

I've also included aloe and poinsettia plants, plus azalea, chrysanthemum, and daffodil flowers. These are terrific decorations that can dress up a windowsill, a dining table, a bureau, or an office desk. And they will stay fresh for a long time.

Materials

» Orange linen duct tape
» Two sheets of aluminum foil,
 12 in. (30 cm) square

Additional Tools

» Panel pattern from website:
 www.richelafabianmorgan.com
» Parchment paper

54. Orange

1 Crumple one sheet of aluminum foil into a ball, then add the second sheet to enlarge the ball. Roll it between your palms for maximum density. The ball should be about 2 ½ in. (6.5 cm) in diameter.

2 Place a 15 in. (38 cm) strip of orange duct tape on top of the parchment paper. Trace the panel pattern on the reverse of the paper and tape strip eight times and cut out.

3 Remove the parchment paper and add the panels to the foil ball one at a time so that the centers are aligned and the points meet at the top and bottom.

55. Aloe Plant

1 Cut a 10 in. (25.5 cm) strip of lime green duct tape. Place it sticky side facing up on the worktable, the long side on the horizontal position. Place a wire strip across the center of the tape. Place a strip of quilt batting on top of the wire, aligning it with the right edge of the tape.

2 Cut a 10 in. (25.5 cm) strip of sour apple duct tape and place it squarely on top of the first strip, sticky side facing down. This is one aloe stem.

3 Fold the stem in half lengthwise with the sour apple duct tape on the outside. The folded side should be the bottom edge. Starting at the bottom left corner, cut ridges 1 in. (2.5 cm) apart and ⅛ in. (3 mm) high. Work in an upward diagonal motion from left to right to make an upside down "V" shape when the stem is unfolded.

4 Repeat Steps 1 through 3 four more times to make five aloe stems.

5 Place the stems on the worktable so the lime green side is facing up and they are aligned vertically. Overlap them at the base by ½ in. (1.25 cm). Hold the stems together at the base using small strips of lime green duct tape.

6 Bring the two sides together to form a ring of stems and secure on the inside with a small piece of lime green duct tape. This is the completed aloe plant. Hold the plant at the base with one hand and gently pull back each stem.

Materials

» Sour apple linen duct tape
» Lime green duct tape
» Wood grain duct tape
» Five 10 in. (25.5 cm) strips of 24-gauge steel wire
» Five 8 in. (20.5 cm) by ¾ in. (2 cm) strips of quilt batting
» One empty duct tape roll
» Newspaper cut into 1 in. (2.5 cm) strips

7 Cover the hole of the empty duct tape roll with strips of wood grain duct tape. Trim the tape down around the perimeter of the roll, leaving a ¼ in. (0.75 cm) tape border. Push down the border over the outside edge of the roll. Cover the outside of the tape roll with a single strip of wood grain duct tape, aligning the long edges of the tape with the edges of the roll. This is the plant pot.

8 Place the pot on the worktable with the open side facing up. Place the plant in the center of the pot. Crumple the strips of newspaper and place inside the pot, and around and inside the plant, making sure the plant doesn't tilt or move.

Materials

» Yellow duct tape
» 1 in. (2.5 cm) strips of newspaper

Additional Tools

» Banana pattern from website:
www.richelafabianmorgan.com

56. Banana

1 Make a double-sided layered fabric 10 in. (25.5 cm) by 9 in. (23 cm). Trace the banana pieces onto fabric and cut out.

2 Attach the pieces together at the outside seams using ¼ in. (0.75 cm) strips of yellow duct tape, leaving an opening at least 3 in. (7.5 cm) wide.

3 Crumple up the strips of newspaper and stuff the inside of the banana. Once it is the desired fullness, cover the opening with yellow duct tape.

57. Mini Palm Tree

Materials

» Lime green duct tape
» Cookie dough duct tape
» Five 8 in. (20.5 cm) strips of 24-gauge steel wire
» Three empty duct tape rolls
» 1 in. (2.5 cm) strips of newspaper

Additional Tools

» Palm tree leaf pattern from website: www.richelafabianmorgan.com

1 Make five double-sided strips of green duct tape 8 in. (20.5 cm) long. Trace the palm tree leaf pattern onto each strip and cut out.

2 Attach a wire down the center of each leaf using strips of green duct tape 8 in. (20.5 cm) long by ¼ in. (0.75 cm) wide.

3 Cut a 2 in. (5 cm) section off one duct tape roll. Close up the gap and wrap a strip of cookie dough duct tape around the roll to secure. This is the bottom of the tree trunk.

4 Cut a 2 ½ in. (6.5 cm) section off the second duct tape roll. Close up the gap and wrap a strip of cookie dough duct tape around the roll to secure. Place it on top of the tree trunk so it partially sits inside the hole.

5 Cut a 3 in. (7.5 cm) section off the third duct tape roll. Set aside the leftover piece. Close up the gap and wrap a strip of cookie dough duct tape around the roll to secure. Place it on top of the second ring of the tree trunk so it partially sits inside the hole. Note that the trunk rings can be crooked.

6 Close up the gap of the leftover piece from Step 5. Place it on top of the third ring of the tree trunk so it partially sits inside the hole. This is the completed tree trunk.

7 Place strips of tape along the inside walls of the tree trunk. Stuff the inside with newspaper.

8 Attach the palm tree leaves to the inside of the top ring of the trunk with strips of green duct tape. Stuff newspaper in the top hole for extra support.

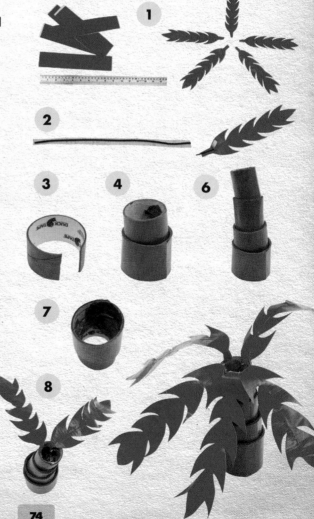

Materials

» Red duct tape
» Yellow duct tape
» Grass duct tape
» Three bamboo skewers

Additional Tools

» Poinsettia petal pattern from website: www.richelafabianmorgan.com Parchment paper

58. Poinsettia plant

1 Using the red duct tape, make a double-sided layered fabric 15 in. (38 cm) by 10 in. (25.5 cm). Trace poinsettia petal pattern eighteen times, and cut out.

2 Take three of the petals and arrange them on the worktable with the bases touching and tops pointing outward. Arrange three more petals on top in the same way. Using strips of red duct tape, attach the six petals together.

3 Repeat Steps 1 and 2 twice more to make three poinsettia flowers. Flip each flower over so taped side is facing down.

4 Cut 15 in. (38 cm) strip of grass duct tape. Place on worktable sticky side up. Cut second 15 in. (38 cm) strip of grass duct tape and place on top of first strip, sticky side down. Cut out five elliptical-shaped leaves that are 3 in. (7.5 cm) long and 1 ½ in. (4 cm) wide. Fold each leaf in half lengthwise. Then cut each leaf in half across the middle.

5 Attach half-leaves to back of the poinsettia flowers, three per flower, with small strips of red duct tape. Discard the extra half leaf.

6 Place a 2 in. (5 cm) strip of yellow duct tape on a piece of parchment paper. Draw three circles ½ in. (1.25 cm) in diameter and cut out.

7 Push pointed end of a skewer through center of one flower from the back, until ⅛ in. (3 mm) is at the front. Wrap strips of red duct tape around skewer on back of the flower.

8 Remove parchment paper from the yellow circles and place at the center of the poinsettia flower. Repeat to make more flowers.

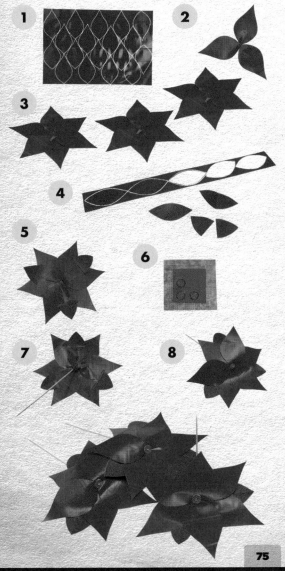

59. Daffodil

Materials

» Yellow duct tape
» Sour apple linen duct tape

Additional Tools

» Daffodil petal pattern from website:
 www.richelafabianmorgan.com

1 Using the yellow duct tape, make a double-sided layered fabric 10 in. (25.5 cm) by 6 in. (15 cm). Trace six petals onto the fabric, cut out, and set aside.

2 From the excess fabric, cut out a rectangle 3 in. (7.5 cm) by 2 ½ in. (6.5 cm). Roll up to form a cylinder 3 in. (7.5 cm) in circumference and 2 ½ in. (6.5 cm) high with the outer edges touching. Secure the edges with a small strip of yellow duct tape.

3 Pinch one of the open ends shut and wrap a strip of duct tape around it. Cut slits 1 in. (2.5 cm) long and ⅛ in. (3 mm) apart all around the opposite end. This is the corona of the daffodil.

4 Fold each of the six petals in half lengthwise. Cut a strip of yellow duct tape ¼ in. (0.75 cm) wide by 4 in. (10 cm) long. Place one petal along the base of the corona and hold it in place with the end of the strip. Continue adding petals and wrapping the strip around the corona. This is the daffodil flower.

5 Cut a 9 in. (23 cm) strip of sour apple linen duct tape. Place it lengthwise on the worktable with the sticky side facing up. Place the daffodil sideways on the left edge of the strip, closest to the top edge. Roll the strip downward, the left edge over the base of the daffodil, tightly winding it to form a stem.

Materials

» White duct tape
» Metallic pink duct tape
» Sour apple linen duct tape

Additional Tools

» Azalea petal pattern from website:
 www.richelafabianmorgan.com
» Parchment paper

60. Azalea

1 Using white duct tape, make a double-sided layered fabric 12 in. (30 cm) by 7 in. (17.75 cm). Trace outer petal pattern onto fabric five times. Cut out the petals and fold each one in half lengthwise. Set aside.

2 Cut 6 in. (15 cm) strip of metallic pink duct tape and place on parchment paper. Trace inside petal pattern five times and cut out.

3 Remove parchment paper from one inside petal and place petal on base of one white petal. Repeat to make five complete petals.

4 Fold 7 in. (17.75 cm) strip of white duct tape in half, sticky sides facing each other, along the width. You should have a double-sided fabric piece that is 3 ½ in. (9 cm) by 2 in. (5 cm). Cut two slightly curved lines 3 in. (7.5 cm) tall from the fabric. These are the stamens. Set them aside.

5 Arrange petals so they fan out in a slight arc. Each petal should be vertical. The tops of the petals should be 1 in. (2.5 cm) apart with bases almost touching. The middle sections should overlap by ½ in. (1.25 cm). Secure on the reverse side using small pieces of white tape near the base.

6 Attach one stamen to the front base of the first petal on the left using white tape. Attach second stamen to center petal in the same way.

7 Cut 3 in. (7.5 cm) strip of white. Pull the left petal toward the right petal to form a circle. Wrap the tape tightly around the base of the petals to form a cone. This is the azalea flower.

8 Cut 6 in. (15 cm) strip of sour apple linen duct tape. Wrap one end around base of the flower. Keep wrapping and twisting strip to form a stem. Pull out petals to form a star.

1

2

3

4

5

6

7

8

61. Chrysanthemum

Materials

» Orange duct tape
» White linen duct tape
» Lime green duct tape

1 Cut a 12 in. (30 cm) strip of orange duct tape. Place it on the worktable with the sticky side facing up. Cut a second strip of orange duct tape and place it squarely on top of the first strip, sticky side facing down. Cut the double-sided strip into four equal 3 in. (7.5 cm) sections.

2 Take one of the 3 in. (7.5 cm) strips and cut into four equal parts lengthwise to make four mini strips that each measure 3 in. (7.5 cm) by ½ in. (1.25 cm). Repeat with the three remaining strips to make sixteen mini strips.

3 Take one of the mini strips and fold it in half lengthwise, with the open edge at the top, and the folded edge at the bottom. Use a pair of scissors to round off the top left corners. Cut a narrow triangle shape at the opposite end, beginning at the top right corners, moving down in a diagonal line, and ending at the folded bottom edge 1 in. (2.5 cm) from the right edge. Unfold. This is one petal. Repeat with the remaining mini strips to make sixteen petals.

4 Cut a 1 ¼ in. (3 cm) diameter circle from the orange duct tape. Place it on the worktable with the sticky side facing up. Take a petal and pinch together the upside down "V" at the base and place the base on the edge of the circle. The petal should stand slightly away from the surface. Add more petals to the circle. To ensure they are equally spaced, add the petals at 12, 3, 6, and 9 o' clock first, to divide the circle into four equal sections. Then add three petals to each section. This is the first layer of petals.

5

6

7

8

9

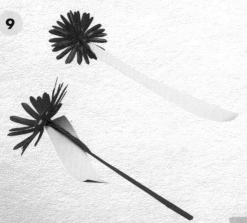

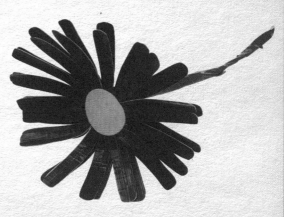

5 Repeat Steps 1 through 4 to make a second layer of petals.

6 Roll up two pieces of orange duct tape with the sticky side on the outside, and attach to the center of the first petal layer. Then place the second layer on top. This is the chrysanthemum flower.

7 Cut a 1 ¼ in. (3 cm) diameter circle from white linen duct tape. Place it sticky side facing down in the center of the flower.

8 Cut a 20 in. (51 cm) strip of lime green duct tape. Make a diagonal cut at one end of the strip.

9 Place the diagonal end of the lime green strip on the center back of the flower and press down. Twist the strip and keep pressing down at the base until a stem begins to form. Continue twisting and rolling the tape downward until the stem is complete. Cut a 6 in. (15 cm) strip of lime green duct tape and wrap it around the stem for extra support.

CHAPTER 7:

Toys

As a parent, I absolutely love making toys with duct tape. Whenever I turn a roll of the stuff into some thingamajig my kids can play with, I transform into the 1980s television character MacGyver. In these moments, my improvised genius takes over and I feel as if I can save the world with a toothpick, some string, and a strip of duct tape.

Because of the DIY movement, we all want to become MacGyvers: makers on the fly, solvers of emergencies with attitude and a pocketknife. But the 21st-century MacGyver has a toolbox that's jam-packed with all sorts of goodies. And the one thing every MacGyver has is duct tape. It is a substrate or tool for every project, the key material that makes something work as well as the adhesive that keeps it together.

The toys in this chapter all require materials found around the house: bamboo skewers, chopsticks, dry rice or beans, some copper pennies, and a pencil. And while you need these little extras to complete the project, make no mistake about what makes it work—it's all about the duct tape.

I'll show you how to make two different kites, a Frisbee, a glider airplane, a hand puppet, a set of juggling sacks, a propeller, a water balloon target, a marshmallow launcher, and a stick puppet. These are all easy-to-moderate projects that you can make quickly. And when your kids see your handiwork, they will admire not only the toy but you, too. So go on: buy that brown bomber jacket and get yourself a mullet haircut—you have just become a MacGyver!

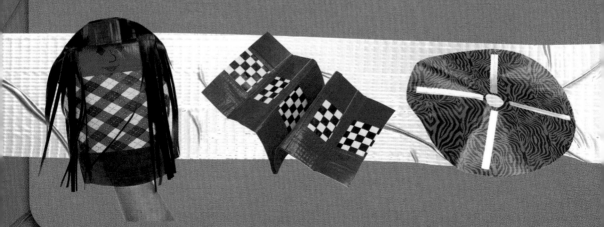

Materials

» Yellow duct tape
» Blue duct tape
» Red duct tape
» Cellophane bag
» ¾ cup of rice (or any other small dried grain, dried bean, or uncooked pasta)
» ¼ measuring cup

62. Juggling Sacks

1 Cut two pieces of cellophane 2 ½ in. (6.5 cm) by 3 in. (7.5 cm). Place one on top of the other. Use narrow strips of blue duct tape to seal three sides to make a sack. Repeat twice more to make a total of three sacks, using red duct tape for one sack and yellow for the other.

2 Fill the sacks with rice. Each sack should hold a little less than ¼ cup of rice. Seal up the opening with matching color duct tape strips.

3 Cut strips of blue duct tape and cover the sides of the sack with yellow edges. Cut strips of red duct tape and cover the sides of the sack with blue edges. Cut strips of yellow duct tape and cover the sides of the sack with red edges.

4 Cut a 3 in. (7.5 cm) strip of blue duct tape. Cut it in half lengthwise, and then cut each piece in half lengthwise. You should have four strips that are 3 in. (7.5 cm) long by ½ in. (1.25 cm) wide. Place strips in an "X" formation on the red sack with blue edges, making diagonal lines from opposing corners. Cut off excess tape. Repeat for the other two sacks, matching the "X" color with the edging color.

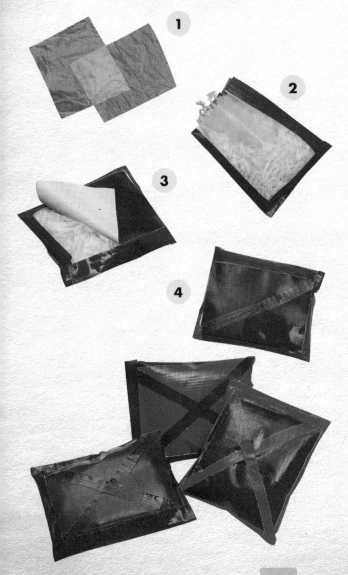

63. Basic Triangle (Delta) Kite

1 Use strips of transparent duct tape to join magazine pages together for a sheet large enough to fit kite pattern, 42 in. (107 cm) wide.

2 Trace pattern onto the magazine pages and cut out. This is the sail.

3 Using transparent duct tape, make a double-sided fabric large enough to fit a triangle 15 ½ in. (39.5 cm) wide by 8 ½ in. (21.5 cm) high by 17 in. (43 cm) on diagonal. Cut out keel.

4 Fold sail in half from nose to tail. Starting 2 in. (5 cm) in from tail, use transparent tape to attach the 17 in. (43 cm) edge of the keel to the folded edge of the sail. The short side of the keel should be closer to the nose of the sail; the long side should be closer to the tail.

5 Using transparent tape, attach one ³⁄₁₆ in. (0.5 cm) diameter dowel to each edge of the sail wings.

6 Flip sail from left to right so keel is underneath. Take the ⅛ in. (3 mm) diameter dowel and place horizontally across sail. Push it toward the nose so it starts to curve as the ends push against the wings. Using transparent tape, attach ends to edges of the wings for spreader.

7 Cut two 40 in. (101.5 cm) strips of blue duct tape. Fold each in half lengthwise. These are the kite tails. Attach one to each side of the sail along bottom edge with transparent tape.

8 Punch three holes in the wing: at "X" spots indicated on kite pattern, and where the keel protrudes. Attach a 40 in. (101.5 cm) length of nylon string to each hole near the wing edges. Tie loose end of the nylon string roll to the other hole. Double knot strings together.

Materials

» Transparent duct tape
» Ocean blue duct tape
» Magazine pages
» Two wooden dowels, ³⁄₁₆ in. (0.5 cm) diameter, 24 in. (61 cm) long
» One wooden dowel, ⅛ in. (3 mm) diameter, 40 in. (101.5 cm) long
» Nylon string

Additional Tools

» Delta kite pattern from website: www.richelafabianmorgan.com
» ⅛ in. (3 mm) hole punch

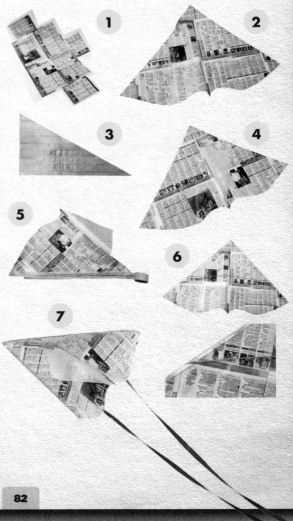

Materials

» Yellow duct tape
» Magazine pages
» Two wooden dowels, ⅛ in. (3 mm) diameter, 24 in. (61 cm) long
» Nylon string

Additional Tools

» Diamond kite pattern from website: www.richelafabianmorgan.com

64. Fighter or Diamond Kite

1 Using ½ in. (1.25 cm) strips of yellow duct tape, join magazine pages to form one large piece to fit pattern, 25 in. (63.5 cm) by 25 ½ in. (65 cm).

2 Trace the kite pattern onto the magazine pages and cut out. This is the sail.

3 Attach one of the wooden dowels along the spine of the sail using 1 in. (2.5 cm) strips of yellow duct tape.

4 Reinforce corners of the sail with 3 in. (7.5 cm) strips of yellow duct tape, folding the excess tape over the edges.

5 Cut two 1 ½ in. (4 cm) strips of yellow duct tape. Make two ½ in. (1.25 cm) parallel horizontal cuts along right edge of each strip and fold over the center to resemble the letter E. Flip over from left to right, sticky side up. These are spreader holders.

6 Position sail so the nose is on top. Measure and mark 2 in. (5 cm) in from each wing corner. Place one of the spreader holders on the 2 in. (5 cm) mark near the left wing corner, positioning the opening of the holder toward sail nose and at a 45-degree angle. Repeat with the remaining holder at the right wing corner.

7 Take the remaining wooden dowel, the spreader. Place ends into spreader holders.

8 Carefully cut holes where indicated by "X" on pattern. Attach a 40 in. (101.5 cm) length of nylon string to the holes near the wing edges. Tie loose end of the nylon string to the hole near the tail. Double knot strings together.

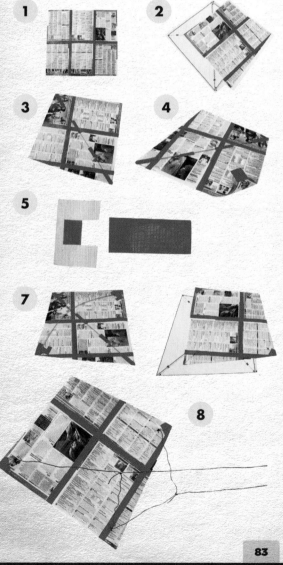

65. Airplane

Materials

» Red duct tape
» Blue duct tape
» Black and white checker duct tape
» Four small coins

1 Make a double-sided, striped layered fabric 12 in. (30 cm) wide by 4 ¼ in. (11 cm) high. The stripes should be red, checker, and blue. Square up the sides.

2 Cut the fabric in half vertically. Then cut each half piece in half vertically to give four fabric pieces 3 in. (7.5 cm) wide by 4 ¼ in. (11 cm) high. Set two of the pieces aside.

3 Cut the remaining two pieces in half vertically to yield four pieces 1 ½ in. (4 cm) wide by 4 ¼ in. (11 cm) high. These are the outer panels.

4 Cut a 4 ¼ in. (11 cm) strip of blue tape. Cut the strip lengthwise into four equal pieces 4 ¼ in. (11 cm) long by ½ in. (1.25 cm) high.

5 Place one outer panel squarely on top of another. Place a strip of blue duct tape lengthwise halfway along the right edge. Fold the strip over the edge, joining the two panels together. Lift the top layer and lay it down to reveal the connected outer panels. Place a second strip of blue duct tape lengthwise halfway along the right edge of the left outer panel. Fold the tape vertically in half. Take the right panel and close it over the left panel. Lift the top layer again so that the outer panels lay open in a slight "V". They should NOT be able to lay flat down. Please note that this applies throughout the rest of these instructions.

6 Repeat Step 5 with the remaining two outer panels. These are the wings.

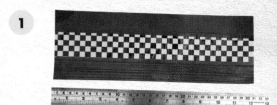

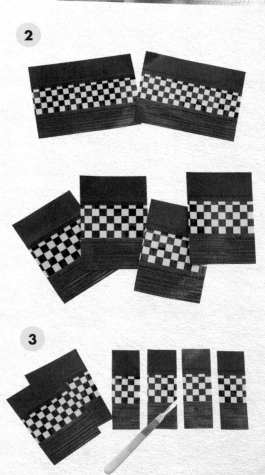

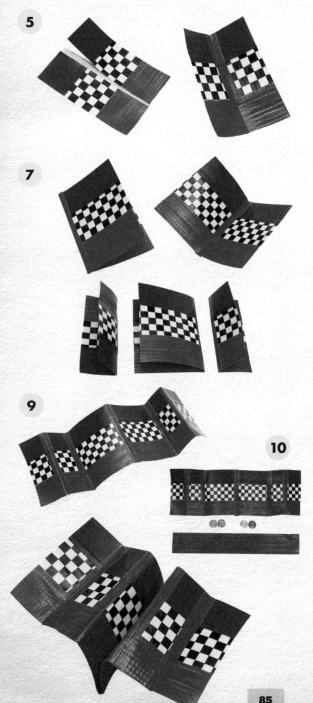

5

7

9

10

7 Take the two remaining panels from Step 2. Place a strip of blue duct tape lengthwise halfway along the right edge. Fold the strip over the edge, joining the two panels together. Lift the top layer and lay it down to reveal the connected outer panels. Place a second strip of blue tape lengthwise halfway along the right edge of the left outer panel. Fold the tape vertically in half. Take the right panel and close it over the left panel.

8 Cut two 4 ¼ in. (11 cm) strips of blue duct tape. Cut each of the strips lengthwise into four equal pieces, 4 ¼ in. (11 cm) long by ½ in. (1.25 cm) high to make eight strips.

9 Close the body. Lay it down so the folded edge is on the left and the open edge is on the right. Take one of the wings and align its open edge with the open edge of the body. Lift the top layer of the wing and place a strip of tape halfway lengthwise along the right edge. Fold the tape over the right edge of the body's top layer only, connecting the wing to the body. Lift the wing and lay it down on the right side, revealing the connected seam from the other side. Place a second strip of blue tape lengthwise halfway along the right edge of the body. Fold the tape vertically in half. Take the wing and close it over the body. Repeat to connect the remaining wing. This is the glider.

10 Flip the glider over. Tape two coins to the bottom edge of each body panel.

66. Water Balloon Target

Materials

» Black duct tape
» Red duct tape
» Ocean blue duct tape
» Yellow duct tape
» Silver chrome duct tape
» Hot rod flames duct tape

Additional Tools

» Parchment paper

1 Using black duct tape make a double-sided layered fabric 12 in. (30 cm) square. Square up the sides. Repeat three more times, using red, blue, and yellow duct tapes.

2 Arrange the fabrics on the worktable in two rows of two, edges touching. Cut a 12 in. (30 cm) strip of silver chrome duct tape. Cut in half lengthwise, then cut each half-strip in half lengthwise again. Use to attach the four fabrics together across vertical and horizontal centers.

3 Cut an 18 in. (45.5 cm) strip of silver chrome tape. Cut it in half lengthwise, then cut each half-strip in half lengthwise again. Use these to make diagonal lines.

4 Cut two 6 in. (15 cm) strips of silver chrome duct tape. Cut strips in half lengthwise, then cut each half-strip in half lengthwise again. From center, measure and mark 8 in. (20.5 cm) down each of the vertical, horizontal, and diagonal lines. Connect the marks from line to line with the strips of tape, making an octagon.

5 Draw or print from a computer ½ in. (1.25 cm) thick numbers that are 2 in. (5 cm) high. Draw four "1"s and four "2"s on parchment paper, cover with strips of silver chrome duct tape and cut out.

6 Peel off parchment paper. Place "1"s inside every other outer trapezoid and "2"s inside every other inner triangle.

7 Draw the number "5" on a piece of parchment paper ½ in. (1.25 cm) thick and 2 in. (5 cm) high. Place a strip of hot rod flames duct tape over the paper and cut out. Peel off the paper and place the number in the center.

Materials

» Purple zebra print duct tape
» Silver chrome duct tape

Additional Tools

» Standard-size dinner plate
» Circles stencil or compass

67. Frisbee

1 Make a double-sided layered fabric 12 in. (30 cm) square. Use zebra print duct tape on one side and silver chrome duct tape on the other. Place the dinner plate on top of the fabric, trace around it, and cut out the circle. This is the frisbee.

2 Fold the frisbee in half, and then fold it in half again to form a triangle. Mark the folded apex.

3 Unfold the frisbee. Draw an "X" on top of the center mark. Then place the circle stencil on top, aligning a 1 ½ in. (4 cm) diameter circle with the "X" and tracing it onto the frisbee.

4 Remove the circle stencil and cut out the circle.

5 Mark four points on the frisbee at 12, 3, 6, and 9 o'clock. Draw a line to connect 12 to 6 o'clock. Then draw a line to connect 3 to 9 o'clock.

6 Starting from the inner circle, cut slits along each of the four lines, stopping ½ in. (1.25 cm) from the outer edge.

7 Cut a 4 in. (10 cm) strip of silver chrome duct tape. Cut the strip lengthwise into four equal pieces, 4 in. (10 cm) by ½ in. (1.25 cm).

8 Along one of the slits, push the sides in toward each other so the panels overlap ¼ in. (0.75 cm). Place a strip of silver chrome duct tape over the slit to secure. Repeat three more times.

1

2

3

4

5

6

7

8

68. Spin Propeller

Materials

» Yellow duct tape
» Blue and white floral duct tape
» Two bamboo skewers
» One chopstick or wooden dowel, ¼ in. (0.75 cm) diameter by 12 in. (30 cm) long

Additional Tools

» Propeller pattern from website: www.richelafabianmorgan.com

1 Cut a 9 in. (23 cm) strip of yellow duct tape. Lay it on the worktable lengthwise and with the sticky side facing up. Cut a 9 in. (23 cm) strip of blue and white floral duct tape. With the sticky side facing down, place it squarely on top of the yellow strip. Trace the propeller pattern on one side and cut out. Repeat to make a second propeller.

2 Trim the bamboo skewers to the same length as the propeller. Arrange the propellers so one propeller has the yellow side facing up and the other has the blue and white floral side facing up, with both propellers in the vertical position and the bases at the bottom edge. Attach a bamboo skewer to the left edge of each propeller with matching strips of tape. This is the backside of the propellers.

3 Flip the propellers so the backsides are facing down. Rotate them so the bases are at the top edge. There will be two protruding arms at the base of each propeller. Cut two yellow duct tape strips 1 in. (2.5 cm) long and ¼ in. (0.75 cm) wide for the propeller with the yellow side facing up. Place one strip on the left arm. Attach the other strip to the right arm, but from the back so the sticky side faces up. Repeat using blue and white floral duct tape strips for the propeller with the floral side facing up.

4 Nestle the chopstick into the base of one propeller about 1 in. (2.5 cm) from the top. Wrap the arms around the chopstick. Attach the remaining propeller on the direct opposite side of the chopstick. Be sure the topsides of the propellers are different colors.

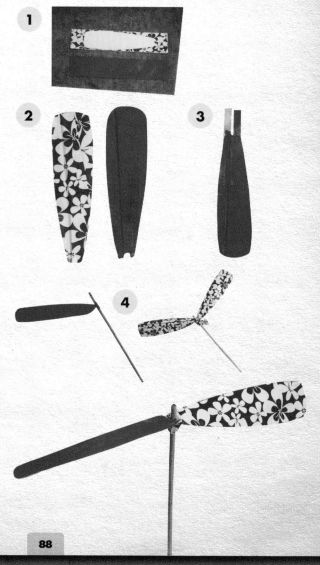

69. Marshmallow Launcher

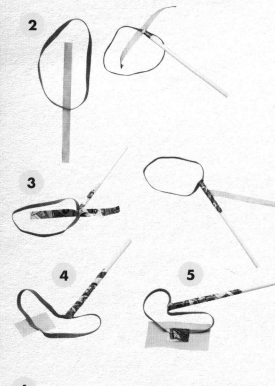

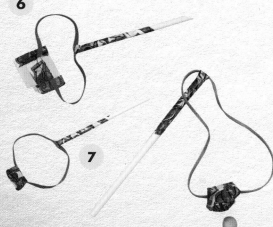

1 Cut 6 in. (15 cm) strip of graffiti duct tape. Cut in half lengthwise, and in half lengthwise again. You should have four 6 in. (15 cm) strips.

2 Take one of the strips and place it on the worktable horizontally, sticky side up. Place one side of the rubber band vertically across the middle of the strip. Then place the eraser end of the pencil on the rubber band. Pull ends of the strip up and press down on the side of the pencil to make the handle.

3 Place a second strip of tape down on the worktable horizontally, sticky side up. Place the handle in the center of the strip, rubber band down. Pull ends of the strip up and press down on the sides of the pencil. Take a third strip and wrap it around at an angle at the top of the pencil, over the previous strips of tape.

4 Cut a 1 in. (2.5 cm) strip of tape and place it on the worktable sticky side up. Place opposite side of rubber band in the horizontal center of the strip. Fold top and bottom edges over rubber band to make shooter.

5 Cut 3 in. (7.5 cm) strip of tape and place on worktable sticky side up. Place shooter across the horizontal middle. Fold left and right sides inward so edges touch the first folded strip, forming an "H". Cut slits along the top and bottom inner vertical edges of the "H".

6 Fold outer pillars of the "H" and fold legs of the pillars inward. Pull sticky sides up and press on the legs, forming a box.

7 Wrap last strip from Step 1 around the bottom of the shooter. Cut off excess tape.

70. Hand Puppet

Materials

» Yellow duct tape
» Denim duct tape
» Pink argyle duct tape
» Black duct tape
» Red duct tape
» Blue duct tape
» Letter size sheet of paper

Additional Tools

» Parchment paper

1 Using the yellow, pink argyle, and denim duct tapes, make two double-sided layered fabrics 10 in. (25.5 cm) wide by 15 in. (38 cm) high. When layering the strips of duct tape, start with two strips of denim at the bottom, followed by three strips of pink argyle, then three strips of yellow.

2 Fold the piece of paper in half lengthwise. Place it on the worktable so the folded side is at the bottom edge. Trim the upper left corners to make an arc. Unfold the paper.

3 Place the two fabrics on top of each other. Place the paper on top of the fabrics and trace around it. Remove the paper and cut out the shape, being sure to cut through both layers of fabric.

4 Using strips of duct tape the same color or pattern as the fabric, attach the two fabrics together at the outer edges EXCEPT at the bottom. This is the puppet body. The yellow section is the head, the pink argyle is the shirt, and the denim is the pants.

5 Cut an 8 in. (20.5 cm) strip of black duct tape. Place it lengthwise on the worktable with the sticky side facing up. Fold the bottom edge up by ½ in. (1.25 cm). Cut a second 8 in. (20.5 cm) strip of black duct tape and place it sticky side facing down over the first strip so that you cover the sticky surface with the second strip and overlap the folded edge by ⅛ in. (3 mm). Flip over from left to right.

6 Cut vertical slits along the bottom edge ⅛ in. (3 mm) apart. Try to end each cut at the top of the sticky border. Do not cut all the way through. These are the puppet's hair bangs.

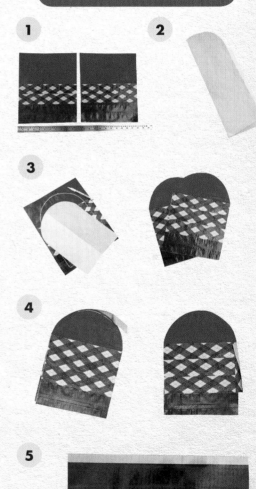

1

2

3

4

5

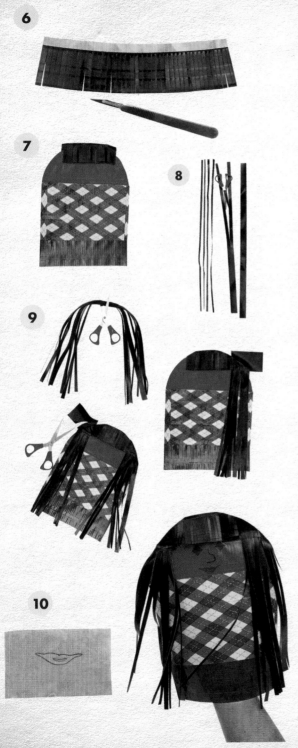

7 Flip the bangs over from right to left and place them on the puppet's head. Cut off excess at the left and right edges.

8 Cut three 24 in. (61 cm) strips of black duct tape. Fold each of them lengthwise, sticky sides facing each other. Then fold each of them in half along the width. Cut each folded strip lengthwise. Cut them again lengthwise until each piece is ¼ in. (0.75 cm) wide.

9 Cut the black duct tape strips at the fold so each piece is now 12 in. (30 cm) long. Divide them into two equal groups. Cut a 3 in. (7.5 cm) strip of black duct tape and lay it on the worktable with the sticky side facing up. Attach strips from one group to the bottom edge of the tape. Then flip it over from left to right and place on the puppet head, at the top and directly to the right of the bangs. Cut off any excess tape around the edges. Cut a second 3 in. (7.5 cm) strip of black duct tape and repeat the step, but place it on the puppet head to the left of the bangs. The puppet hair is complete.

10 On parchment paper draw a pair of lips that are 1 in. (2.5 cm) wide. Cover the drawing with a small strip of red duct tape and cut out, keeping the parchment paper in place. This is the lips sticker.

11 Remove the parchment paper from the sticker and place the lips on the puppet head. Cut two ½ in. (1.25 cm) squares of blue duct tape. These are the eyes. Place the eyes on the puppet head. Cut out a backwards question mark 1 in. (2.5 cm) long from black duct tape. This is the nose. Place it on the puppet head.

71. Moving Stick Puppet

1 Cut a 12 in. (30 cm) strip of blue and green plaid duct tape. Fold it in half lengthwise, the sticky sides facing each other. Cut strip in half to make two 6 in. (15 cm) double-sided strips. These are the arms.

2 Cut a 13 in. (33 cm) strip of denim duct tape. Fold it in half lengthwise, the sticky sides facing each other. Cut strip in half to make two 6 ½ in. (16.5 cm) double-sided strips. These are the legs.

3 Using the plaid duct tape make a double-sided layered fabric 4 in. (10 cm) wide by 3 in. (7.5 cm) high. Square up the sides. Rotate the fabric 90 degrees so the 3 in. (7.5 cm) edges are at the top and bottom. Wrap a strip of denim duct tape completely around the bottom edge. This is the body. The lower portion is the top of the puppet's pants and the upper portion is the shirt.

4 Cut a 4 in. (10 cm) strip of yellow duct tape. Fold the tape in half across the width, sticky sides facing each other. You should have a double-sided 2 in. (5 cm) strip. Cut the top left and right corners off at 45-degree angles so the strip looks like a baseball home plate. This is the head.

5 Cut a 2 in. (5 cm) strip of yellow duct tape. Fold it in half lengthwise, sticky sides facing each other. This is the neck.

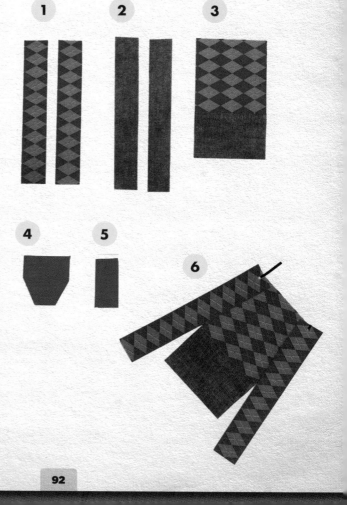

8

9

6 Punch a hole at the top of each arm. Punch a hole at the left and right top corners of the body, where the shoulders should be. Cut two thin strips of black duct tape 2 in. (5 cm) long by 1/16 in. (1.5 mm) wide. Line up the holes in the arms with the holes in the body and thread a strip of tape through each set of aligned holes. Wrap the tape around the body and the arms.

7 Punch a hole at the top of each leg. Punch a hole at the left and right bottom corners of the body, where the hip sockets should be. Cut two thin strips of black duct tape 2 in. (5 cm) long by 1/16 in. (1.5 mm) wide. Line up the holes in the legs with the holes in the body and thread a strip of tape through each set of aligned holes. Wrap the tape around the body and the legs.

8 Flip over the body. Attach the neck to the top edge with a strip of blue and green plaid duct tape. Place the head underneath the neck. Make sure the wider edge is at the top. Attach the head to the neck with a small piece of yellow tape.

9 The basic structure of the puppet is now complete. Decorate the front of the head by adding eyes, nose, mouth, and hair. Add shirt cuffs, collar, and a bow tie to the shirt. Draw on parchment paper first, and then cover the drawing with tape. Make the drawings into stickers by cutting out the shapes, peeling off the parchment paper, and placing them on the puppet.

10 Flip the puppet over and attach the stick to the back of the puppet with a strip of blue and green plaid tape.

CHAPTER 8:

Costumes

If you have ever made a costume or disguise with duct tape, then you can already describe its wondrous qualities. For those of you who have never done so, this chapter will open your eyes. Need a pair of bunny ears? Make it out of duct tape. What about a Mardi Gras mask? Duct tape is your answer. The stuff is colorful, bright, sturdy, and (best of all) water resistant. Whatever your imagination can muster, you can make it with duct tape. And it will last longer than the occasion it was made for. Family and friends might even ask to borrow that pair of giant gloves or giant shoes you wore last Halloween, or the Groucho Marx-style eyebrows and mustache you had for a friend's costume party many months ago. A little wipe with a damp sponge will make them good as new!

All of the costumes and disguises in this chapter are ones that I've made for my own use or for my kids. The one that holds a special place in my heart is the tree limb. About four years ago, my daughter, Masana, became enamored with the changing foliage during the fall. When I asked her what she wanted to be for Halloween that year, her answer came as no surprise—she wanted to be a tree. However, trees are stationary while my young, energetic daughter is not. To get around this, I dressed her from head to toe in brown clothing and made a tree limb for each arm. Masana was able to walk, prance, dance, jump, twirl, and more. She wore some extra leaves in her hair, but the tree limbs really made her feel truly arboreal. She would strike a tree pose whenever possible, extending her arms out and transforming her body into a giant Y. Admirers would call out, "That's one tree-mendous costume, little girl!!" It was simply the best costume I ever made her.

72. Rabbit Ears

Materials

» White duct tape
» Metallic pink duct tape
» Two 24 in. (61 cm) lengths of 24-gauge steel wire
» Headband, sweatband, or hat

Additional Tools

» Parchment paper

1 Using the white duct tape make a single-sided layered fabric on top of a sheet of parchment paper. It should measure 16 in. (40.5 cm) wide by 12 in. (30 cm) high.

2 Flip fabric over so the parchment paper is facing up. Peel off the paper and rotate the fabric so the 16 in. (40.5 cm) side is vertical. Fold each length of wire in half and place them vertically, side by side, on the fabric with the folded ends at the top. The base width of each folded wire strip should be 3 ½–4 in. (9–10 cm). There should be at least 1 in. (2.5 cm) between the two wire strip bases.

3 Using white duct tape build a single-sided layered fabric on top of the first fabric, covering over the wires.

4 Cut in half vertically, between the two folded wires. Trim excess tape around the wires, leaving a ¼ in. (0.75 cm) border. These are the bunny ears.

5 Trim the base of each ear so it is the desired overall height.

6 Place strips of metallic pink duct tape on top of the parchment paper. Cut out two tall, rounded triangles, two-thirds of the size of the white bunny ears. These are the inner ear stickers.

7 Peel off the parchment paper from the back of the inner bunny ear stickers. Then place one sticker on each white ear, centered.

8 Wrap bottom ends around headband or sweatband, or tape bottom ends to a hat.

73. Mardi Gras Mask

Materials

» Black and white houndstooth duct tape
» Black duct tape
» String

Additional Tools

» Mask pattern from website: www.richelafabianmorgan.com
» Bone folder (optional)
» ⅛ in. (3 mm) hole punch

1 Using the houndstooth duct tape make a double-sided layered fabric 13 in. (33 cm) by 7 in. (17.75 cm). Trace the mask pattern onto the fabric and cut out.

2 Fold the nose section in half lengthwise. Use the bone folder to tighten the fold by running its edge up and down against the fold. Fold the main mask in half between the eyes. Use the bone folder to tighten the fold.

3 Attach the nose to the main mask using small strips of black duct tape. The tape should be placed on the back of the seam between the nose and the main mask while the pieces are folded. The nose attaches to the bottom edge of the main mask, in the fold between the eyes.

4 Cut two 2 in. (5 cm) strips of black duct tape. Flip them over so the sticky side is facing up. Pull the bottom edges up and fold over, sticky sides facing each other, leaving an exposed sticky side border ¼ in. (0.75 cm) wide along the top edges.

5 Starting at the bottom edges, cut ½ in. (1.25 cm) vertical slits into each folded strip, ⅛ in. (3 mm) apart. These are the eyelashes.

6 Place the eyelashes along the inside top edges of each eyehole in the mask. The sticky edge should be facing down so that you can fold it in and over to the backside of the mask. Cut ¼ in. (0.75 cm) slits into the sticky edge so that it folds over easily and the eyelashes will attach snugly to the rounded edge of the eyehole.

7 Trim the outer edges of the eyelashes, rounding the shape.

8 Punch holes into the sides of the mask and attach string.

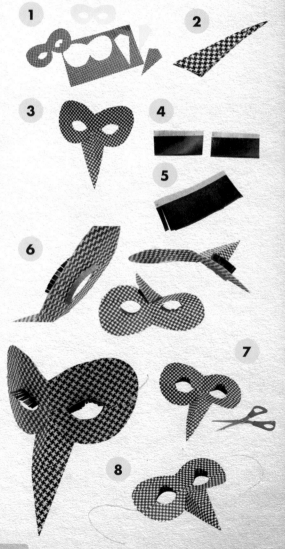

Materials

» White duct tape

Additional Tools

» One sheet of paper, 9 in. (23 cm) by 12 in. (30 cm)

74. Giant White Gloves

1 Place the paper on the worktable horizontally. Place your hand on top of the paper, draw a giant glove shape around your hand, and cut out the shape. This is the pattern.

2 Make four double-sided layered fabrics that each measure 12 in. (30 cm) by 9 in. (23 cm). Trace the pattern on top of each fabric and cut out the shapes. Divide into two sets of two.

3 Cut two 12 in. (30 cm) strips of duct tape. Cut them lengthwise so they are each ¼ in. (0.75 cm) wide.

4 Attach the fabrics together by placing the strips of tape along the outside seams. Be sure to keep the bottom edges open.

1

2

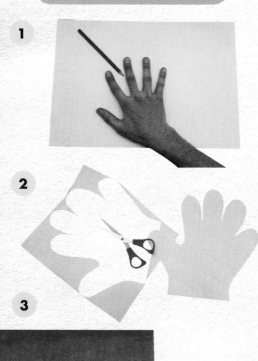

3

4

75. Giant Shoe Feet

Materials

» Black duct tape
» Diamond plate duct tape

Additional Tools

» Sheet of paper, 14 in.
(35.5 cm) by 17 in. (43 cm)

1 Place the sheet of paper on the floor vertically. Place your foot on top of the paper and trace a 2 in. (5 cm) border around your foot. Cut out shape. This is the shoe pattern.

2 Using the black duct tape, make two double-sided layered fabrics that each measure 14 in. (35.5 cm) by 17 in. (43 cm). Trace the pattern on top of each fabric and cut out the shapes. Flip one left to right. These are the tops of the shoes.

3 Cut holes into each shoe top big enough to slip your foot through, at least 6 in. (15 cm) in diameter. Set aside.

4 Make two double-sided layered fabrics that each measure 14 in. (35.5 cm) by 17 in. (43 cm). The outside of each fabric should be black and the reverse diamond plate. Trace the shoe shape on the black side of one fabric. Flip pattern from left to right and place on the black side of the second fabric. Trace pattern and cut out the shape. These are the bottoms of the shoes. The soles are the diamond plate sides; place them facing down.

5 Cut four 12 in. (30 cm) strips of black duct tape. Then cut them in half lengthwise.

6 Pair up the left top with the left bottom, and the right top with the right bottom. Place feet through each hole in the shoe tops. The outer edges will not match; the tops will fall short of the outer perimeter of the bottoms. Place tape where the tops of the shoes touch the bottoms.

7 Remove feet from shoes. Add extra strips of black duct tape around the edges of the back of each foot opening.

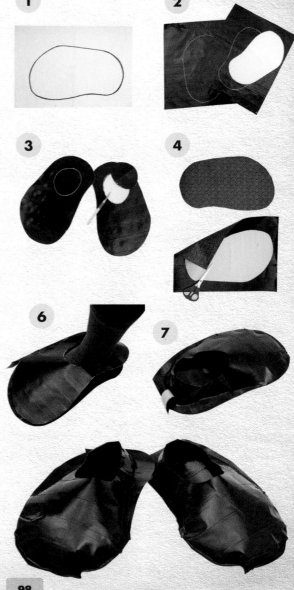

Materials

» Black duct tape

76. Mustache and Eyebrows

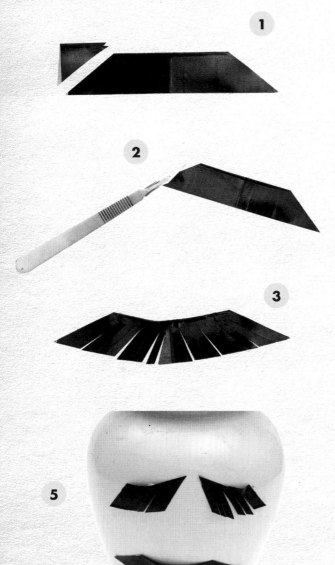

1 Cut a 5 in. (13 cm) strip of black duct tape. Fold it in half lengthwise, sticky sides facing each other, to make them double-sided.

2 Fold strip again along the width so the overall length is 2 ½ in. (6.5 cm). Hold strip with the folded edge on the right. Starting at the bottom left corner, cut tape on upper left corner at a 45-degree angle.

3 Starting at the bottom edge, cut ½ in. (1.25 cm) long slits into the fabric parallel to the diagonal left edge and ⅛ in. (3 mm) apart. Stop at the right-hand folded edge. Unfold fabric. This is the mustache.

4 Repeat Steps 1 and 2.

5 Starting at the bottom edge, cut ½ in. (1.25 cm) long slits into the fabric parallel to the diagonal left edge. When you get to the right folded edge, cut all the way through so there are now two separate pieces. Rotate each of them 180 degrees. Then flip one of them left to right. These are the eyebrows.

77. Alien Wig

Materials

» Silver chrome duct tape

Additional Tools

» Fitted baseball cap (optional)

1 Cut six 24 in. (61 cm) strips of silver chrome duct tape. Fold them in half lengthwise, sticky sides facing each other, to make them double-sided. Cut them in half to make 12 in. (30 cm) double-sided strips. Cut each strip in half again to make 6 in. (15 cm) strips.

2 Cut each strip in half lengthwise. Then cut each strip in half lengthwise again. You should now have 96 strips 6 in. (15 cm) long by ¼ in. (0.75 cm) wide. These are the hair.

3 Cut a 12 in. (30 cm) strip of duct tape. Cut in half lengthwise. Flip over strips so the sticky sides are facing up. Place the tops of the hairs across the bottom edges of the strip. Pull the top edge down and over, covering the tops of the hairs. These are hair strips. Repeat until you have used all the hair.

4 Use small pieces of silver chrome duct tape to attach hair strip ends together to form a "skirt" that will fit around your head. Attach row after row of hair strips to the top of the skirt on the inside, making it progressively smaller as it gets to the top. If possible, use a fitted baseball cap to gauge girth of the wig.

5 Repeat Steps 1 through 3 for additional hair strips to finish the top section.

6 Add hair strips to the bottom of the skirt. These strips do not go all the way around the head. They would cover the back of the head.

7 Cut slits into individual wig hairs to make the wig fuller.

Materials

» Metallic pink duct tape
» Gold duct tape

Additional Tools

» ⅛ in. (3 mm) hole punch

78. Rock Star Wig

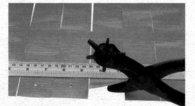

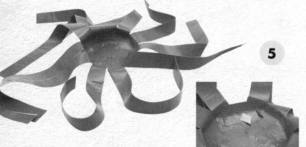

1 Using the metallic pink duct tape make eleven 24 in. (61 cm) double-sided strips. Line them up on the worktable side-by-side, top edges aligned.

2 Run a thin strip of metallic pink duct tape horizontally across the strips, 5 in. (13 cm) from the top edges.

3 Punch a hole in the center of each strip 1 in. (2.5 cm) from the top edges.

4 Arrange the top edges of the strips so that the holes are aligned and join them together with pieces of metallic pink duct tape on the inside of the strips. This is the basic wig.

5 There will be a small gap between the first and last strip. Make a 3 ¼ in. (8.25 cm) double-sided strip of metallic pink duct tape. Place this strip in the gap and attach it to the inside of the wig with small pieces of metallic pink duct tape.

6 Cut long slits into the strips of the wig to make the hair.

7 Make more double-sided strips with metallic pink and gold duct tapes. They can be various lengths. Cut long slits into them and attach to the wig with thin strips of tape. Repeat until you get the desired shape and fullness.

79. Crown

Materials

» Gold duct tape
» Red duct tape
» Blue duct tape
» Silver chrome duct tape

Additional Tools

» Parchment paper

1 Using the gold duct tape, make a double-sided layered fabric 22 in. (56 cm) wide by 4 ½ in. (11.5 cm) high. Square up the sides.

2 Make into a cylinder and attach edges with a thin strip of gold duct tape on the inside and outside. This is the basic crown.

3 Flatten the crown. Starting from the top left corner, cut into the crown at a 45-degree angle, about 2 in.(5 cm) down. Then continue cutting up at a 45-degree angle, making a "V" shape. Continue cutting "V" shapes into the top edge, 1 in. (2.5 cm) high and 1 in. (2.5 cm) apart, until you have five "V"s. Then cut vertically across to the right edge. Unfold the crown.

4 Draw diamond shapes of various sizes onto the parchment paper. Cover diamond shapes with red, blue, and silver chrome duct tape. Flip parchment paper over so you can see the drawn diamond shapes from the backside. Cut out diamond shapes. These are the jewel stickers.

5 Peel off the parchment paper from the back of the jewel stickers. Add stickers to the outside of the crown.

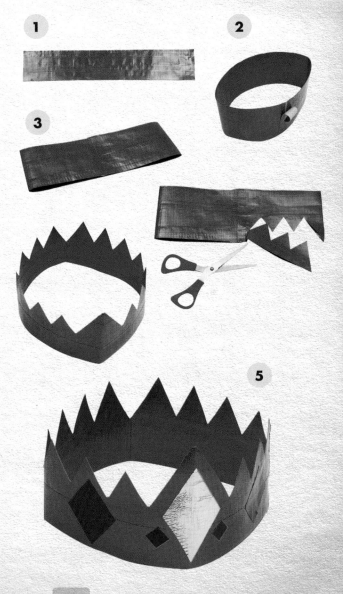

Materials

» Green wavy duct tape
» Black duct tape

Additional Tools

» Zoot Suit Man stencil on page 52
» Parchment paper

80. Stencil patch

1 Using the black duct tape, make a single-sided layered fabric directly on top of a piece of parchment paper. Square up the sides.

2 Enlarge the zoot suit stencil to the size that will fit inside the black fabric. Trace the stencil onto the parchment paper. Make a single-sided layered fabric on top of the parchment paper using the green wavy tape. Flip over fabric to reveal the stencil from the backside. Cut out sticker.

3 Peel off parchment paper from the zoot suit man sticker and place on top of the black fabric.

4 Remove the parchment paper from the black fabric and place on clothing as a decoration or to disguise a tear.

1

2

3

81. Tree

Materials

» Wood grain duct tape
» Grass duct tape
» Two 36 in. (91.5 cm) strips
 of 24-gauge steel wire

Additional Tools

» Tulip tree leaf pattern from
 website:
 www.richelafabianmorgancom

1 Cut two 36 in. (91.5 cm) strips of wood grain duct tape. Lay strips on the worktable horizontally and with the sticky sides facing up. Place a strip of steel wire at the lower edges of each strip. Pulling from the bottom edge, roll strips up and over the steel wire. Roll the tape strips until they form two long, narrow cylinders with the wire inside. These are the tree limbs.

2 Using the grass duct tape, make four 27 in. (68.5 cm) double-sided strips. Trace the leaf pattern onto the strips and cut out 40 leaves. Fold each leaf vertically in half. Divide the leaves into two piles of 20, one for each tree limb.

3 Cut 40 strips of wood grain duct tape ¼ in. (0.75 cm) wide by 5 in. (13 cm) long. Place one end of the strip vertically along the base of a leaf. Wrap the middle of the strip twice around the tree limb, and then attach the remaining end to the reverse side of the leaf. Repeat until all the leaves are attached to the limbs.

4 Wrap tree limbs around your arms.

Materials

» White duct tape
» Black and white gingham duct tape

82. Tuxedo Dickey

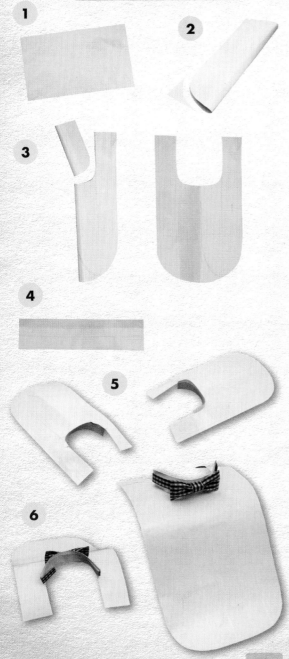

1 Using the white duct tape make a double-sided fabric 16 in. (40.5 cm) wide by 10 in. (25.5 cm) high.

2 Fold fabric in half lengthwise then rotate 90 degrees so vertical sides measure 16 in. (40.5 cm). With folded edge on right side, cut the top left corner so it is rounded.

3 Rotate fabric 180 degrees. Folded edge should now be on the left side. Starting the cut from folded edge 4 in. (10 cm) from the top corner, cut a half "U" into the fabric, ending the cut 3 in. (7.5 cm) to the right of the folded edge. Open up fabric to reveal a full "U" shape cut into the middle of the top edge and the bottom edge corners rounded. This is the basic dickey. The "U" is the neck area.

4 Cut 8 in. (20.5 cm) strip of white duct tape. Place horizontally on the worktable sticky side up. Pull up bottom edge and fold over, making a ½ in. (1.25 cm) white border at the bottom. Cut second 8 in. (20.5 cm) strip of duct tape and place on top of the first strip, sticky sides facing each other. The bottom edge of the second strip should be ¼ in. (0.75 cm) from the bottom edge of the first strip. Flip over from left to right so sticky side of second strip faces up. This is the collar.

5 Place collar inside neck area of the dickey, sticky edge facing down at the bottom. Cut ¼ in. (0.75 cm) slits into sticky edge, ½ in. (1.25 cm) apart. Fold slits down so sticky edge attaches to the back of the dickey.

6 Make a bow tie from page 19 using gingham tape. Place bow tie around collar. Attach straps to the backside of the collar with white duct tape.

Holiday

Festive accents around the home can be provided by simple duct tape crafts. Its bright colors and cheerful patterns give you a head start, and many of the projects in this chapter can be made in less than an hour. Whether you are throwing an intimate dinner party, or serving cocktails to a large group of friends, you can create holiday ambiance with very little work.

There are some fun holiday projects, but my most reliable one is the wine glass markers. First of all, you can make them with the little sticky bits left at the end of a duct tape roll, so you can start making them before you even have a party planned. This also makes full use of your precious duct tape. Just fold the tape into small, double-sided pieces and save them in a small plastic bag or box. You can cut the shape out later. Secondly, they can double as party souvenirs that guests can take home at the end of the night. They can also be used in lieu of place cards on a dinner table by personalizing each one with a permanent marker. The wine glass markers in this chapter are heart-shaped, but you can cut an alternative shape or size to suit the occasion.

In addition to the markers, this chapter provides you with two different-sized banners, ornaments large and small, a Christmas calendar, an ice bucket, gift tags, and a holiday card.

Materials

» Silver chrome duct tape
» Yellow duct tape
» Blue and green plaid duct tape
» Red duct tape
» Black and white damask duct tape

Additional Tools

» Thick-tipped black permanent marker

83. Small Banner

1 Cut a 30 in. (76 cm) strip of silver chrome duct tape. Cut a ½ in. (1.25 cm) wide strip lengthwise from the larger strip. Fold in thirds lengthwise. This is the banner string.

2 Fold 4 in. (10 cm) strips of tape over the string to make double-sided rectangles approximately 1 ¾ in. (4.5 cm) by 2 in. (5 cm). Space them approximately ½ in. (1.25 cm) apart and hanging down from the string.

3 From the upper left and right corners of each rectangle, cut downward toward the middle of the bottom edge. This will convert each rectangle into a triangle. This is your banner.

4 Draw letters inside the banner. Tie the ends of the string to a mantle, wall, window, or chair.

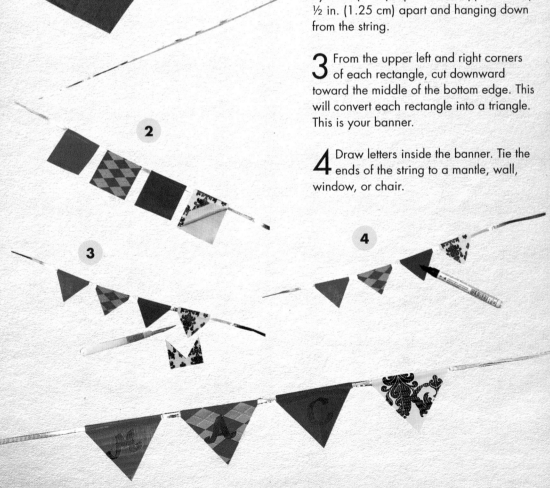

84. Christmas Calendar

Materials

» White knitted duct tape
» Green duct tape
» Red duct tape

Additional Tools

» Thick black marker
» Green string

1 Using the green and white knitted duct tape make a double-sided layered fabric 11 ½ in. (29 cm) wide by 14 in. (35.5 cm) high. Square up the sides. Rotate the fabric 90 degrees so the pattern shows green and white horizontal knitted stripes.

2 Place a strip of red tape across the top edge of the fabric so it overlaps by ½ in. (1.25 cm). Fold the strip down and around the back of the fabric so that it overlaps by ½ in. (1.25 cm). It should add ½ in. (1.25 cm) to the height of the fabric. Repeat Step 2 across the bottom edge of the fabric, adding another ½ in. (1.25 cm) to the fabric. This is the calendar base.

3 Using the green and white knitted tape, make another double-sided layered fabric 12 in. (30 cm) wide by 5 ¼ in. (13.5 cm) high. Square up the sides.

4 Rotate fabric 90 degrees so it is 12 in. (30 cm) high. Divide the fabric into three strips, each measuring 1 ¾ in. (4.5 cm) wide by 12 in. (30 cm) high. Then divide each strip into 1 ½ in. (4 cm) high strips, equally dividing each strip into eight sections to make twenty-four rectangles. Rotate all of the pieces so the horizontal edges measure 1 ¾ in. (4.5 cm). These are the pockets. Arrange the pockets in four rows of six on the calendar base.

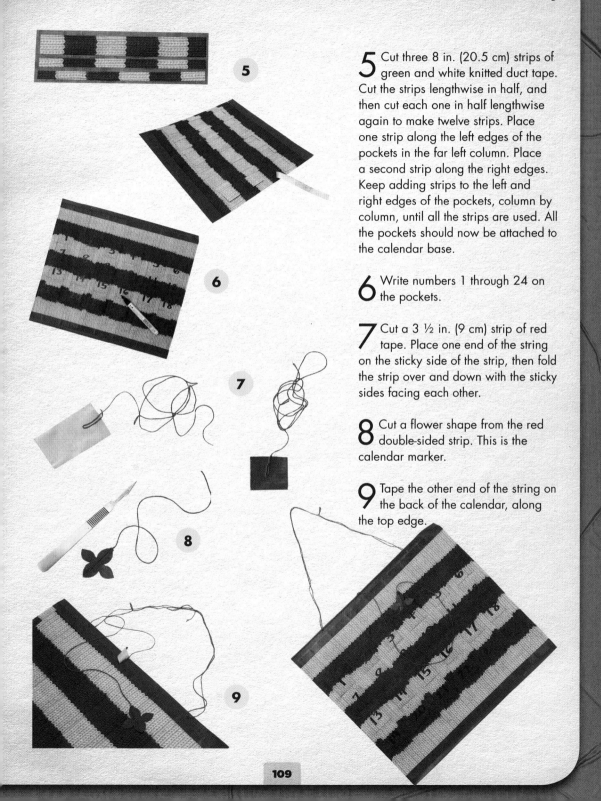

5 Cut three 8 in. (20.5 cm) strips of green and white knitted duct tape. Cut the strips lengthwise in half, and then cut each one in half lengthwise again to make twelve strips. Place one strip along the left edges of the pockets in the far left column. Place a second strip along the right edges. Keep adding strips to the left and right edges of the pockets, column by column, until all the strips are used. All the pockets should now be attached to the calendar base.

6 Write numbers 1 through 24 on the pockets.

7 Cut a 3 ½ in. (9 cm) strip of red tape. Place one end of the string on the sticky side of the strip, then fold the strip over and down with the sticky sides facing each other.

8 Cut a flower shape from the red double-sided strip. This is the calendar marker.

9 Tape the other end of the string on the back of the calendar, along the top edge.

85. Round Pillow Ornament

Materials

» Red duct tape
» Black and white damask duct tape
» 24 in. (61 cm) of string, any color
» 1 in. (2.5 cm) strips of newspaper

Additional Tools

» One full duct tape roll
» ⅛ in. (3 mm) hole punch

1 Make two double-sided layered fabrics 5 in. (13 cm) square, one from red duct tape, and the other from black and white damask duct tape. A full roll of duct tape should be able to fit within the outside edges of each fabric.

2 Place the roll of tape onto the black and white damask fabric. Trace the inside and the outside circles. Repeat on the red fabric. Cut around both outside circles.

3 Place one fabric circle directly on top of the other so the outer edges align. Punch 16 holes ½ in. (1.25 cm) apart around the inner circle, making sure you punch through both fabrics.

4 Thread the string through the holes, going in and out, until you have gone through 14 of the holes.

5 Widen the opening. Crumple strips of newspaper and stuff in between the two fabrics until the desired size has been reached.

6 Thread the string through the two remaining holes. Tug to gather the fabric edges. Tie a double-knot to hold everything in place.

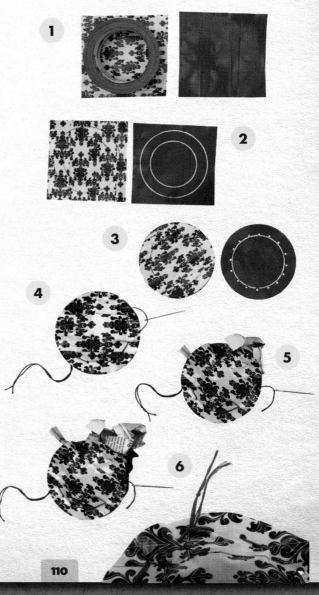

Materials

» Green grass duct tape
» Red duct tape
» 72 in. (183 cm) string

Additional Tools

» Computer printout of letters

86. Letter Banner

1 Using your computer, create a text document from which you can print out the letters for your banner. Use a sans serif font, such as Helvetica or Arial. Make the letters about 3 ½ in. (9 cm) high. Print out letters and cut them out.

2 Using the green grass duct tape, make a double-sided layered fabric that is large enough to fit your letters inside. Place paper letters on top of the fabric and trace them. Cut out the letters.

3 Using the red duct tape, make a double-sided layered fabric that measures 5 in. (13 cm) wide by 4 in. (10 cm) high. Fold in half vertically and cut out half of a heart shape. Unfold fabric. This is the heart.

4 Arrange letters and heart on the worktable. Use small strips of green grass duct tape to attach the string to the backs of the heart and letters near the top edges.

87. Wine Glass Markers

Materials

» Orange linen duct tape
» Blue chevron duct tape
» Black and white houndstooth duct tape
» Blue and green plaid duct tape
» Four wine glasses

Additional Tools

» ⅛ in. (3 mm) hole punch

1 Cut one 3 in. (7.5 cm) strip of tape in each of the four colors. Fold the strips in half vertically, sticky sides together. Fold the strips in half again vertically. Cut half of a heart shape. Unfold strips. You should have four hearts. These are the markers.

2 Punch a hole in the upper left side of each marker.

3 Cut a 6 in. (15 cm) strip of orange duct tape. Cut it in half lengthwise. Discard one strip. Cut the other strip in half lengthwise again. Then fold each piece in thirds. Repeat with a 6 in. (15 cm) strip of blue chevron tape to make four folded strips. These are the ties.

4 Fold each tie in half. Push the folded end of one tie through the hole of one marker, forming a loop. Take one of the loose tie ends and push it through the loop. You are ready to attach the marker to a wine glass.

5 Wrap the remaining loose tie around the stem of a wine glass, then push it through the loop.

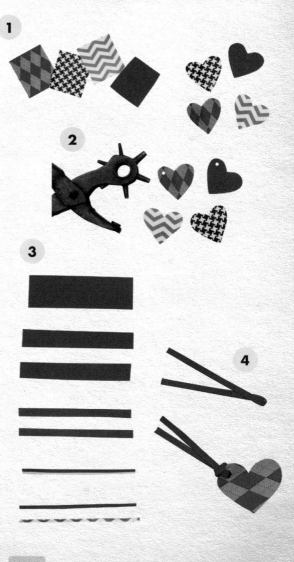

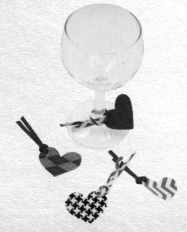

88. Hanging Ball Ornament

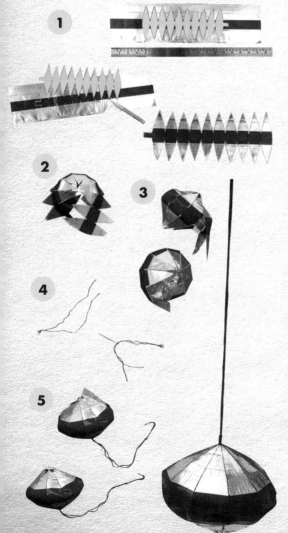

1 Make a double-sided layered fabric 14 in. (35.5 cm) wide by 4 ½ in. (11.5 cm) high. Start at the center with a long strip of red duct tape. Build outward, adding strips of silver tape to the top and bottom edges. Place the pattern on top of the fabric, aligning the horizontal center with the central red strip. Trace the pattern onto the fabric, then cut out.

2 Using small strips of silver duct tape, attach the edges of each "V" together. You will see a ball forming. Leave two "V"s on one side unattached.

3 Place a small piece of tape on the back of the tab. Pull the tab over and place it behind the opposite edge, taping the ball shut. Place strips of silver tape on the back of the adjacent seams, closing them. The ball should be entirely closed except for the two unattached "V"s at one of the polar ends.

4 Thread the button with the red string, placing it in the center for the length of string. Thread both ends of the string through the sewing needle. Push needle through the opening of the ball and out through the opposite (closed) end. Pull the needle until the button prevents you from pulling the thread any further. Remove the needle. Tie a knot at the base of the strings closest to the ball. Tie a second knot in the loose ends.

5 Close up the remaining two "V"s from the back with small pieces of tape. Cut a small circle ¾ in. (2 cm) in diameter of the silver chrome duct tape. Place the circle at the bottom polar end of the ball.

89. Hanging Party Decoration

Materials

» Blue and white snowflake duct tape
» White duct tape
» 36 in. (91.5 cm) string

Additional Tools

» Compass
» Snowflake pattern from website: www.richelafabianmorgan.com
» ⅛ in. (3 mm) hole punch

1 Make a double-sided layered fabric that measures 10 in. (25.5 cm) square, the front side snowflake duct tape and the back white. Using the compass, draw a circle with a radius of 4 ½ in. (11.5 cm) and a diameter of 9 in. (23 cm) and cut out. Then draw an inner circle with a radius of ¾ in. (2 cm) and a diameter of 1 ½ in. (4 cm) in the center. Cut out the inner circle and discard.

2 Trace the snowflake pattern on the back of the fabric. Punch two holes where indicated, just inside of the inner circle edge.

3 Starting from the back, thread the string through the holes, weaving it in and out. After threading the string through the last hole, gently tug to close up the inner circle. Tie a double knot at the base of the string to secure the inner circle.

4 Cut out the snowflake pattern.

5 Punch a hole in one tip. Thread the string attached to the center of the snowflake through the hole.

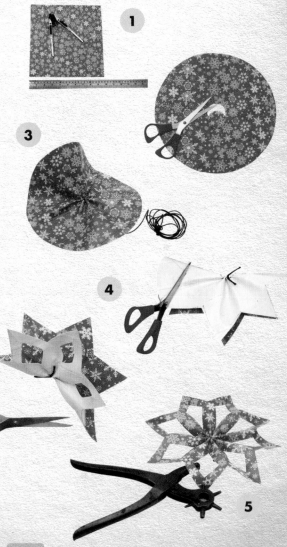

Materials

» Basket weave duct tape
» Holiday reindeer duct tape

90. Wine Chiller

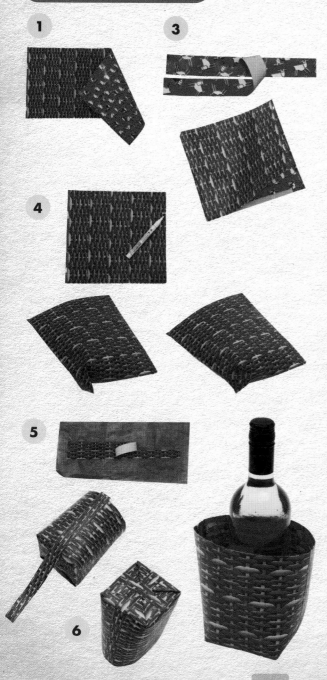

1 Make a double-sided layered fabric 8 in. (20.5 cm) wide by 15 in. (38 cm) high. The basket weave tape should be on the front, and reindeer tape on the back. Square up the sides.

2 Fold the fabric in half horizontally and position it so the folded edge is at the bottom.

3 Cut a 7 in. (17.75 cm) strip of reindeer duct tape and cut it in half lengthwise. Pull back the top layer along the left and right edges of the folded fabric, and place these strips of tape halfway and vertically along the edges of the bottom layer, sticky side facing down. Pull the outer edges back so the strips of tape are folded in half vertically, sticky side facing up. Place the top layer back again, closing up the edges.

4 Along the bottom edge mark 2 in. (5 cm) in from the left corner. Pinch from the left edge and bottom edge to form a triangle at the left corner. Pull the triangle down toward the bottom and fold at the 2 in. (5 cm) mark. Secure with a small piece of tape. Repeat on the right side. This is the wine chiller.

5 Cut a 12 in. (30 cm) strip of basket weave duct tape. Cover the outside seams with this strip. The ends will overlap at the bottom. Fold down the excess tape along the top edge.

6 Cut a piece of basket weave tape 4 in. (10 cm) wide by ½ in. (1.25 cm) high. Place it along the center of the base of the wine chiller, perpendicular to the previous tape strips.

91. Gift Tags

Materials

» Holiday reindeer duct tape
» White linen duct tape

Additional Tools

» ⅛ in. (3 mm) hole punch
» Extra-fine point black permanent marker

1 Cut a 24 in. (61 cm) strip of reindeer duct tape. Place it on the worktable in the horizontal position with the sticky side facing up. Cut a 24 in. (61 cm) strip of white linen duct tape and place it squarely on top of the reindeer strip, sticky side facing down. The top and bottom edges of both strips should be aligned as much as possible.

2 Cut the double-sided strip into 3 in. (7.5 cm) pieces. Punch holes on the upper left corner of each piece, white linen side facing up. These are the tags.

3 Cut a 6 in. (15 cm) strip of reindeer duct tape. Cut horizontally into ¹⁄₁₆ in. (1.5 mm) wide strips. These are the tag strings.

4 Push one end of a string carefully through a hole in one of the tags. Fold the string and connect the loose ends to each other.

5 Write on the white linen side of the tag.

1

2

3

5

To: Tom
Happy Holidays!
From Mae

Materials

» White linen duct tape
» Red duct tape
» Silver chrome duct tape

Additional Tools

» Parchment paper

92. Holiday Card

1 Using the white linen duct tape, make two double-sided layered fabrics 5 in. (13 cm) wide by 7 in. (17.75 cm) high. Square up the sides.

2 Cut a 7 in. (17.75 cm) strip of red duct tape. Cut in half lengthwise. Discard one of the strips. Cut the other strip lengthwise in half again. Lay the two fabrics on the worktable side by side in the portrait position (i.e. the vertical side is the longer side). Align the bottom edges and be sure there is ¹⁄₁₆ in. (1.5 mm) between the inner vertical edges. Attach the two fabrics by placing a strip of red tape centrally along the inner vertical edges. Flip over from left to right. Again, place the remaining strip of red tape along the inner vertical edges. This is your base card.

3 Draw eight ellipses 1 ½ in. (4 cm) wide by 1 in. (2.5 cm) high. Cover with red duct tape. Flip the parchment paper over so you can still see the outline of the ellipses. Cut out shapes. These are the flower petal stickers. Peel off the parchment paper from the back of each sticker. Carefully place them on the front panel of the card in a flower formation: four on the bottom, then four on top.

4 Cut a ½ in. (1.25 cm) diameter circle out of silver chrome duct tape. Place the circle in the center of the flower.

1

2

3

4

CHAPTER 10:

Just for Fun

The following projects were originally created on the fly and mostly out of desperation. I needed "something" right then and there, but that particular something was nowhere to be found. So what did I do? I turned to my supply of duct tape for salvation.

I won't lie to you: I tinkered with some projects before including them in the book. My original tree swing didn't have PVC pipes or grommets because, well, I was desperate! And I'm not the sort who has extra PVC pipes and grommets lying around the house. When I made that first one, my kids were dangerously playing on a broken swing in our yard. I had to make something to replace it and do so quickly (or else suffer their wrath since they LOVED that broken swing). So I made a duct tape seat and knotted the salvaged rope from the old swing around the sides. And though it worked

perfectly, I always thought that I could have made it better if the circumstances were not so dire.

This section is filled with many "if I only had more time" projects, and I actually considered making that the title of this chapter. The improved tree swing is the one that I wish I had made for my kids. The same goes for the piggy bank, utility basket, eye mask, coupon holder, and hot beverage sleeve. But there were projects that were fine as they were because they involved repairing something, such as a sports watchband.

Another project that didn't need improvement is the mobile. I originally made this with a precocious six-year-old, mainly to stop her destroying my house. With duct tape leftovers that were originally meant for wine glass markers, paper clips, and string, we made a mobile worthy of a modern art museum. How awesome is that?

93. Utility Basket

1 Use silver duct tape to make a double-sided layered fabric 24 in. (61 cm) square. Square up the sides. Fold fabric in half horizontally. Position so folded edge is bottom.

2 Cut two 12 in. (30 cm) strips of silver duct tape. Along left and right edges of folded fabric, pull back top layer and place strips vertically halfway along edges of the bottom layer, sticky side down. Pull outer edges back so strips of tape are vertically folded in half, sticky side up. Place top layer back again, closing up edges.

3 Along bottom edge mark 5 in. (13 cm) in from left corner. Pinch from left edge and bottom edge to form a triangle at left corner. Pull triangle down toward the bottom and fold at the mark. Hold in place with tape. Repeat on the right side. This is the basket.

4 Cut two 20 in. (51 cm) strips of digital camouflage duct tape. Cover outside seams with these, overlapping at the bottom. Fold down excess tape along top edge.

5 Cut four 6 in. (15 cm) strips of digital camouflage duct tape and use to cover the triangle edges along the bottom of the basket.

6 Cut two 10 in. (25.5 cm) strips of digital camouflage duct tape and use to cover the inside seams at the bottom of the basket.

7 Using pliers, bend the wire into a 10 in. (25.5 cm) by 14 in. (35.5 cm) rectangular frame, attaching excess wire to the wire frame.

8 Place the frame inside the perimeter of the top edge of the basket. Cover the frame by folding strips of digital camouflage tape lengthwise over the top edge of the basket.

1
2
3
4
5
6
7
8

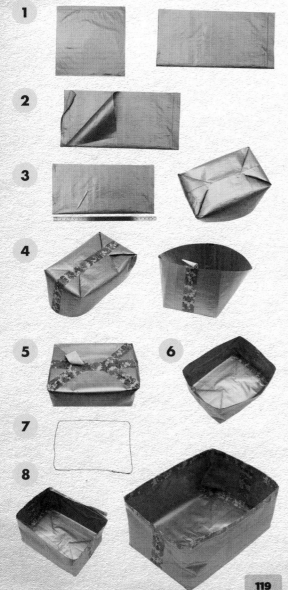

94. Tree Swing

1 Make a double-sided layered fabric that measures approximately 25 in. (63.5 cm) wide by 6 in. (15 cm) high.

2 Fold the fabric in half lengthwise. Cut off the corners on a curve, rounding the edges. Unfold the fabric and leave it on the worktable in the horizontal position.

3 Cut four 2 in. (5 cm) strips of tape. Place one strip on the left and right edges of the fabric, 1 in. (2.5 cm) from the edge and in the center. Then flip the fabric over and repeat. You are reinforcing the fabric in these areas.

4 Using the grommet kit, cut a hole approximately 1 ½ in. (4 cm) in from the left edge, on top of the reinforced sections. Then attach a grommet with a hammer. Repeat on the right edge.

5 Place the elbows in the 1 in. (2.5 cm) holes of the T joint. Push the elbow in with some force to secure its place. Thread one end of the rope through one of the grommets and pull it through approximately 24 in. (61 cm). Tie a double knot.

6 Take the other end of the rope and thread it through one side opening of the elbow/T combo. Pull it through the middle hole. Throw rope over a tree branch. Thread rope back through the middle hole. Pull it through the other elbow opening, and keep pulling until you have the desired height of the swing.

7 Thread rope through the remaining grommet and tie a double-knot.

Materials

» Real tree wood camouflage duct tape
» Grommet kit, plus two ¼ in. (0.75 cm) grommets
» One PVC T joint, 1 in. (2.5 cm) by 1 in. (2.5 cm) by ¾ in. (2 cm)
» Two PVC elbows, ¾ in. (2 cm)
» ⅜ in. (1 cm) rope, 75 ft. (22.8 m) long

Additional Tools

» Hammer

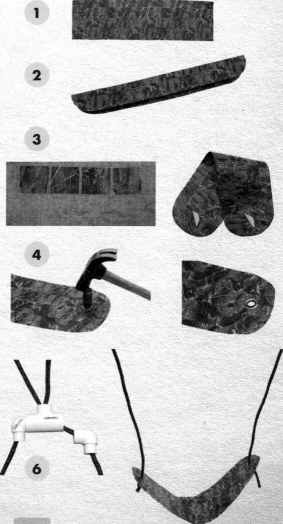

95. Drying Strip for Flowers or Hot Peppers

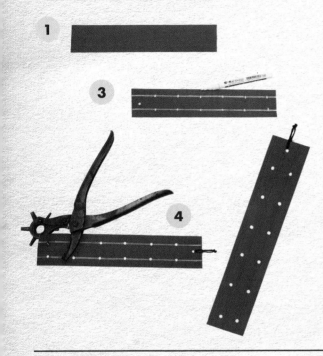

1 Cut a 20 in. (51 cm) strip of duct tape. Fold in half to make a double-sided strip 10 in. (25.5 cm) long. Move the strip to the vertical position on the worktable.

2 Punch a hole in the center of the top edge, ½ in. (1.25 cm) from the edge. This is the hanging hole.

3 With a pencil, draw a vertical line ½ in. (1.25 cm) from the left edge. Then draw a second vertical line ½ in. (1.25 cm) from the right edge. Measure and draw a small horizontal line across both vertical lines at 1 ½ in. (4 cm) intervals.

4 Punch holes at every intersection marked in Step 3.

96. Fixing a Sports Watchband

1 Working with 1 in. (2.5 cm) strips of tape, wrap the strips tightly around the rip in the band. Use as many strips as needed to repair the rip.

97. Coupon Holder

Materials

» Blue paisley duct tape
» White linen duct tape
» Two pieces of cardboard, 3 ½ in. (9 cm) by 8 in. (20.5 cm)

1 Place the two cardboard pieces on the worktable in the vertical position and ½ in. (1.25 cm) apart. With the blue paisley duct tape, make a single-sided layered fabric over the cardboard, starting ½ in. (1.25 cm) below the bottom edge of the cardboard pieces. The fabric should overlap the cardboard pieces by ½ in. (1.25 cm) at the outer edges, with an overall measurement of 8 ½ in. (21.5 cm) wide by 9 in. (23 cm) high. Square up the side.

2 Flip fabric over from left to right. Cut off all four corners of the fabric at a 45-degree angle so the cut almost touches the corners of the cardboard.

3 Fold the outer edges of the fabric over the cardboard. Then place a strip of blue paisley duct tape down the vertical center. Trim off excess tape at the top and bottom edges. This is the outer case.

4 Using the white linen duct tape, make two double-sided layered fabrics that measure 3 in. (7.5 cm) wide by 7 ½ in. (19 cm) high. Square up the sides.

5 Place the white linen fabrics on top of the outer case. Align each piece so that it is ½ in. (1.25 cm) from each edge.

6 Cut an 8 in. (20.5 cm) strip of blue paisley duct tape. Cut it in half lengthwise, then cut each half strip again in half lengthwise. Vertically place a strip of tape along the left edge, attaching the white fabric to the outer case. Then vertically place a strip along the right edge, attaching the second white fabric to the outer case.

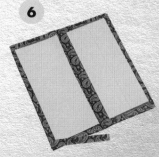

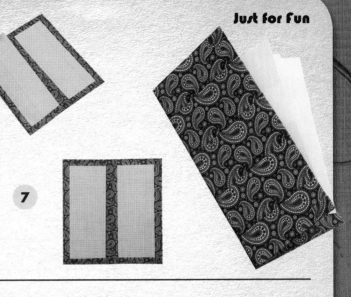

7 Cut the remaining two strips from Step 6 in half horizontally and use to attach the white fabric to the outer case by placing them horizontally on the top and bottom edges. Fold over any excess tape.

7

Materials

» Wood grain duct tape
» Blue chevron duct tape
» Cardboard beverage sleeve

Additional Tools

» Parchment paper

98. Reusable Hot Beverage Sleeve

1 Using the blue chevron duct tape, make a double-sided layered fabric 5 in. (13 cm) wide by 6 in. (15 cm) high.

2 Fold the cardboard sleeve in half. Trace the sleeve onto the fabric twice and cut out the shapes.

3 Join the two shapes along the back and front outer edges with ¼ in. (0.75 cm) wide strips of wood grain duct tape. This is the hot beverage sleeve.

4 Write letters on parchment paper, then cover with a strip of wood grain tape. Flip paper over to reveal the letters on the backside and cut them out.

5 Peel off the parchment paper and place the letters on the hot beverage sleeve.

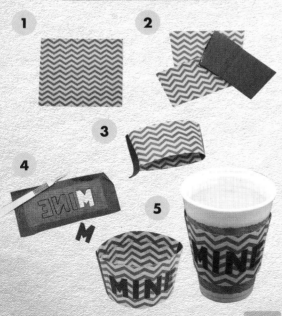

99. Mobile

1 Cut 4 in. (10 cm) strips of tape from every color duct tape except black. Fold strips in half vertically, sticky sides together.

2 Cut folded strips into a variety of shapes, geometric or free-form.

3 Punch a hole into each shape. Attach a string to each hole and tie a double knot.

4 Use the pliers to unfold and flatten the paper clips into straight lengths of wire.

5 Cut nine small strips of black duct tape approximately 1/16 in. (1.5 mm) by 1 in. (2.5 cm).

6 Take two of the shapes and double knot one string to each end of one straightened paper clip. Make one string shorter than the other. Reinforce the knots by folding strips of black tape over them.

7 Tie a string to the middle of the straightened paper clip. Hold the string up and balance the shapes that are tied to the end by shifting the paper clip back and forth. When you get to the point where the shapes are balanced, place a strip of tape on the middle knot to secure.

8 Repeat Steps 6 and 7. Play with the length of the strings and make them different from the previous two.

9 Attach the loose strings of the two mobile pieces to the ends of another flattened paper clip. Cover knots with black tape strips. Then tie another string

Materials

» Red duct tape
» Yellow duct tape
» Orange duct tape
» Purple zebra duct tape
» Multicolored chevron duct tape
» Three standard-size paper clips
» Eight pieces of string, each 8 in. (20.5 cm) long

Additional Tools

» 1/8 in. (3 mm) hole punch
» Flat nose pliers

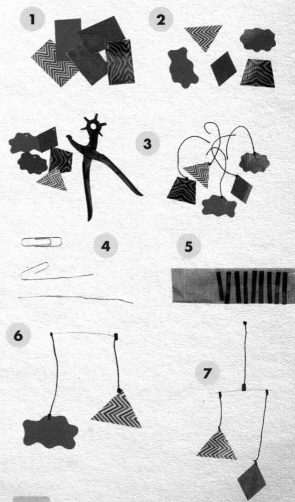

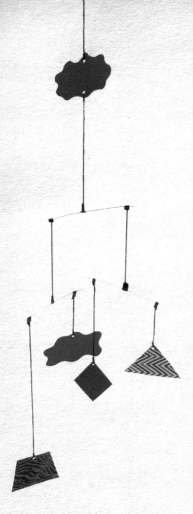

100. Sleeping Eye Mask

Materials

» Blue chevron duct tape
» Soft black fabric, such as faux velvet or velour, at least 9 in. (23 cm) by 3 ½ in. (9 cm)
» Length of ¼ in. (0.75 cm) black elastic, 10 in. (25.5 cm) long

Additional Tools

» Parchment paper
» Eye mask pattern from website: www.richelafabianmorgan.com

1 Use the tape to make a single-sided layered fabric on top of parchment paper, 9 in. (23 cm) by 3 ½ in. (9 cm). Trace the pattern on top of the fabric and cut out. This is the eye mask.

2 Peel off the parchment paper and place the eye mask on top of the black fabric. Trim around the edges, removing any excess fabric.

3 Attach the ends of the elastic band to the left and right edges of the eye mask with small strips of duct tape.

to the middle of the paper clip. Hold the string up and balance the mobile pieces attached to the paper clip by shifting it back and forth. When you get to the point where the shapes are balanced, place a strip of tape in the middle knot to secure the placement.

10 Punch a second hole in the remaining unattached shape, directly opposite from the first one. Double knot the loose end of the string attached to the rest of the mobile to the hole of the shape. This is the finished mobile.

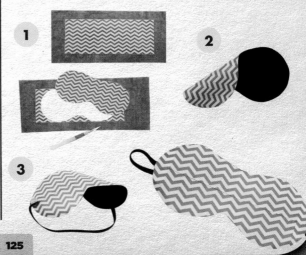

101. Coin Piggy Bank

Materials

» Flamingo pink duct tape
» Black duct tape
» Two empty duct tape rolls
» One sheet of letter-size paper
» Two wine bottle corks

Additional Tools

» Parchment paper

1 Tape the rolls together from the inside, forming a cylinder. Leave a small gap approximately ⅛ in. (3 mm) between the strips of tape. Within the gap, leave an opening that is at least 1 in. (2.5 cm) long.

2 Cover the outside of the rolls with four strips of pink tape, placing the strips across the cylinder from edge to edge. Fold excess tape over the edge. There should be an uncovered section, exposing the gap between the rolls.

3 Place the cylinder on top of the sheet of paper. Trace around the cylinder twice to make two circles. Remove cylinder and cut out circles.

4 Place one circle on top of the cylinder, covering the top hole. Place two strips of pink duct tape over the paper. Cut the excess tape around the cylinder, leaving a ¼ in. (0.75 cm) border. Fold down the tape border, enclosing the top hole.

5 Flip the cylinder over and repeat Step 4 with the remaining paper circle.

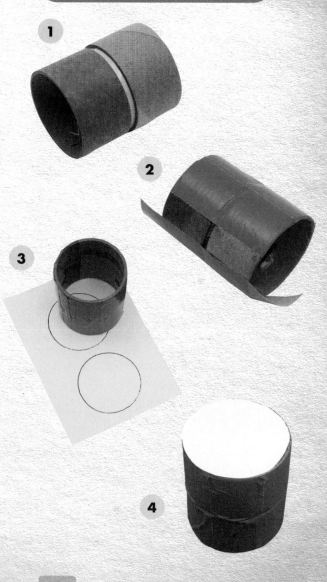

5

6

7

8

6 Cover the outside of the cylinder with a strip of pink duct tape, aligning it to the top edge of the cylinder. Take a second strip of pink duct tape and cover the cylinder, aligning it to the bottom edge. This is the body of the piggy bank. There should be an opening on the top to insert coins. Fold down any tape that is hindering the opening by inserting the blade of scissors and pushing it in.

7 Cut a ½ in. (1.25 cm) strip of tape. Fold it vertically in half, sticky sides facing each other. You should have a 1 ¼ in. (3 cm) double-sided strip. Cut it in half diagonally. These are the pig's ears. Tape them to one of the flat sides of the pig's body. This is now the face.

8 Decorate the face with eyes, nose, and mouth. Draw them on parchment paper, place black duct tape on top of the drawings, flip over to reveal the drawings on the backside, and cut out. Peel off the parchment paper and place stickers on the pig's face.

9 Lay the piggy bank on the worktable, the opening facing up. Place the wine corks on opposite sides of the body, touching it. Wrap a strip of tape around the body and the corks to hold them in place.

9

Online Resources

General Materials:
Uline, www.uline.com

General Art and Craft Supplies:
A. I. Friedman, www.aifriedman.com
Amazon, www.amazon.com
Dick Blick Art Materials, www.dickblick.com
Jerry's Artarama, www.jerrysartarama.com
Michaels, www.michaels.com
Pearl Fine Art Supplies, www.pearlpaint.com
Tape Brothers, www.tapebrothers.com
Utrecht Art Supplies, www.utrechtart.com

Trimming:
M&J Trimming, www.mjtrim.com
Trim Fabric, www.trimfabric.com

Sewing and Quilting Supplies:
Home-Sew Inc., www.homesew.com
Sew True, www.sewtrue.com

Duct Tape Brands and Manufacturers:
3M, www.3m.com
Duck Brand, www.duckbrand.com
Nashua, www.nashua.com
Platypus Designer Duct Tape,
www.designerducttape.com

Hair Accessories:
Factory Direct Craft, www.factorydirectcraft.com

Acknowledgments

The success of *Tape It & Make It* paved the way for this second set of 101 duct tape projects. I could chalk it up to serendipity, but I know better: many people pitched in and kept the faith.

There are my collaborators at Quintet. Mark Searle: thank you for putting our book on the global map. Ross Fulton: I'm going to miss you! Caroline Elliker: it was such fun! How did you do that? And can we do it again? Thanks. Hazel Eriksson: thanks for simply being you!

Then there are collaborators who gave me ideas when they didn't need to. Juliet: again?? Tom: I couldn't have made the kites without you, you toy-making savant. Masana: not only are you my daughter, you are a duct tape genius!

My friends at Barron's believed not only in the book but in me. Ellen Sibley, Jackie Raab, and Pat Doyle: thank you for your incredible support. Every writer should be so lucky! Eric Lowenhar: all I can say is "thank you." But you must know that without you I am nothing.

I dedicate this book to my dad, a loving man who is sometimes misunderstood.

Dad: I love you today and always.

About the author

Richela Fabian Morgan began her duct tape odyssey six years ago with a simple bi-fold wallet, before writing *Tape It & Make It* and *Tape It & Make More*. She is as an indie crafter specializing in paper, adhesives, and found materials, and has taught various craft projects at elementary schools, public libraries, and charitable organizations around the US. She has written several books and blogs regularly on *richelafabianmorgan.com*.

Richela lives in Larchmont, New York, with her husband and two crafty kids.